PROMAKEUP
DESIGN BOOK

Published by
Laurence King Publishing Ltd
361–373 City Road
London EC1V 1LR
Tel: +44 20 7841 6900
email: enquiries@laurenceking.com
www.laurenceking.com

Co-written and edited by Hannah Kane
Creative direction and makeup by Lan Nguyen-Grealis

A catalogue record for this book is available from
the British Library.

ISBN 13: 978 1 78627 549 3

Commissioning editor: Jo Lightfoot
Senior editor: Gaynor Sermon
Designer: Amira Prescott
Face chart illustrations by Dena Cooper

Printed in Italy

Laurence King Publishing is committed to ethical
and sustainable production. We are proud participants in
The Book Chain Project ®
bookchainproject.com

Supported by

PROMAKEUP
DESIGN BOOK

Lan Nguyen-Grealis

Laurence King Publishing

FOREWORD

Lan has acted as Makeup Director of internationally distributed women's lifestyle magazine PHOENIX since the very early days of its inception in 2010. Lan and I had met sometime before that, when I was asked to interview her backstage at London Fashion Week for a newspaper. I remember being impressed with how she was the picture of calm in a sea of glamorous chaos!

I've spent many years watching Lan work on editorial and celebrity cover shoots for PHOENIX magazine and, more so than many of the other makeup artists I know, she is completely involved in the overall art direction of the shoot and has a clear picture of how the final image needs to look. You can be sure there will always be moodboards and reference images pinned to the walls of the studio for the team to refer to and to help communicate ideas.

I was pleased to be able to co-write and edit Lan's first book, *Art & Makeup*, and I am excited for people to read and enjoy our second collaboration, *ProMakeup Design Book*, which delves more into the practical side of creating a look. If you love fashion, makeup or beauty and feel the urge to be creative but don't always know where to start, then this book of inspirational images and face-chart templates is the perfect kit to get you started.

When I lecture at universities and colleges on various aspects of the creative industries, such as art direction, journalism and fashion photography, I often tell people that one of the most important ways to develop as an artist is to be prolific: whether you are a painter, illustrator, writer or photographer, there is no better way to learn than 'on the job'. However wild your ambitions are, it all begins with a small step. What could you do today to help further your goals? Perhaps it's designing a face chart for the makeup for a school play; if you're an emerging makeup artist it could be working on looks for a catwalk show; or maybe you just need a killer look for Halloween and want to up your Insta-game.

The artistic principles in this book do not just apply to makeup, and don't be surprised if, once you understand the principles of colour theory, you start to look at your wardrobe in a whole new light!

Finally, don't forget to share your face charts and completed makeup looks on social media tagging @lanslondon @laurencekingpub @phoenixmaguk using the hashtag #promakeupdesignbook – we'd love to see what you create!

Hannah Kane
Writer and Editor-in-Chief
PHOENIX Magazine

CONTENTS

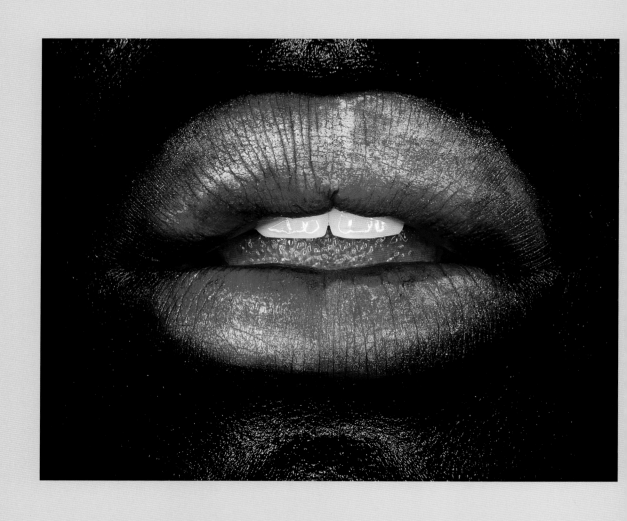

INTRODUCTION

From an early age, when it came to art and design, I can always remember planning a look and practising it first before handing in my final design. I would make notes along the way and fix mistakes to ensure the best possible outcome, something that I was proud to show off. There is nothing more satisfying than when you can physically hold and show something tangible that you have made. It's a way of logging a memory through a piece of art that you have created.

Hours of planning can go into creating a look, and afterwards makeup is wiped away clean, never to be seen again. These days we can easily generate photographic evidence to share what we have created, but before social media and digital photography your look might have been just a memory. Even if you were lucky enough to work with a professional photographer, you often couldn't see the finer details or evidence of the long hours that had gone into creating the look.

Ideas are always passing fleetingly through our minds, so get them down on paper and make them a reality. I created this book as an ideas book for your creative adventures. At the back you will find blank face-chart templates ready for you to unleash your creativity. You can tear these out and share them, photograph and post on Instagram, or keep them in the book to showcase your range of looks and skills.

Face charts have long been used by professional makeup artists to accurately record and share a look for others to copy, for consistency: when working with a team on a runway show, for example, or to ensure continuity over the course of a TV series. It's an essential part of the kit to have face charts with design details and instructions as to what products were used. It is really helpful to see the breakdown of the design look, especially for character work. It is a key part of the creative process.

No book will give you the winning formula to be the 'best' makeup artist, or we would all be exactly the same! Instead of trying to think like anyone else, for each makeup look you consider, ask yourself if there's anything different and original you could bring to it.

Now, pull out a face chart and start designing!

DESIGNING A LOOK

Makeup is used to create looks for a variety of purposes, from magazines, also known as editorial, to memorable stage looks for musicians, trend-setting looks on the catwalk, as part of the brand image for a company's advertising communications, as well as design for TV, film and theatre. Makeup can be used to create an image for a person or a brand, whether retro or futuristic, avant-garde or classic, playful or serious, minimalist or maximalist.

When you are designing a look, think about the distance from which the makeup will be viewed. Beauty shoots in magazines are usually close-up crops, so that the reader can see all the detail of the makeup. On the catwalk, makeup looks are viewed at a distance of several feet, even by the VIPs on the front row. On-screen you can see close-ups of the actor's face, whereas in the theatre the viewer might be in the back row.

In the fashion and beauty industries we prepare a moodboard ahead of every shoot. A moodboard is basically a collection of inspirational images that you can use to gather your thoughts and communicate them to a colleague or client. Everything is inspiration! Research material could include film stills, paintings, screen icons or historical figures, album artwork, colour palettes, striking architecture or interesting landscapes. It's easy to search for images online, but remember that if the photo is protected by copyright then you can only use it for personal use. Secondary research material includes images of other makeup artists' and photographers' work that you've seen in magazines or advertising campaigns. You can be inspired by other artists' work, but it's important to always put your own stamp on an idea.

EVERY PART OF THE FACE HAS A STORY, JUST ASK YOURSELF, WHAT STORY ARE YOU TELLING?

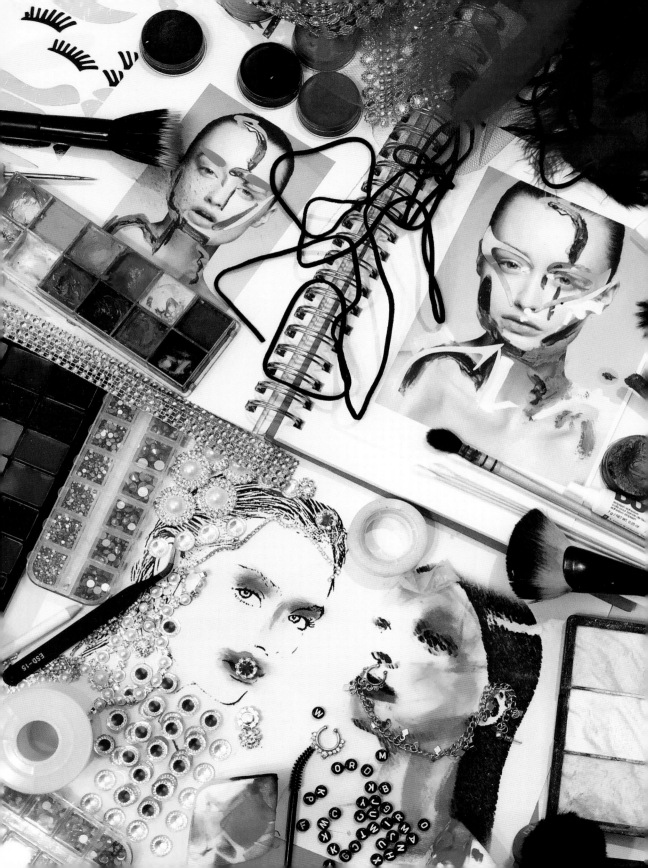

USING THE FACE CHARTS

When planning a look, I always begin with a moodboard and ideas for themes. I then map out the essential areas that I want to highlight or bring into focus. I break the look down and practise with different combinations of colours and materials before finally designing it on a face chart and tweaking it to suit. Having my idea down on a face chart makes it easier to communicate the look to my clients and to my team, especially for my show work.

LIPSTICK TRICKS
Use your fingers to give the impression of smoothness, and a flat brush for detailed work. Always coat with clear nail polish: either matte or shiny for extra detail.

GLITTER APPLICATION
Use a flat brush or your finger to sweep a smooth layer of craft glue on to the paper, and pour a little glitter over it evenly. Finally, use a soft brush or fan brush to fill the gaps and brush off any excess glitter.

CREAM AND POWDER APPLICATION
Use dabbing, circular motions to layer and build up colour. Always dab on to the back of the hand first to remove any excess, before applying directly to the paper in thin layers.

METALLICS
Shimmer powder or metallic powder can be mixed into a paste by dampening with water and mixing on a palette. Apply lightly with a flat brush and sweep softly over the face for the desired effect.

HIGHLIGHT AND CONTOUR
Add lighter areas to highlight, enhance and define. Using light tones creates the illusion of the shape coming forward, while darker-toned contouring gives the impression of bone structure, drawing the features back for a three-dimensional effect.

You can use these principles to play with the proportions of the face and enhance or subdue features: elongating around the nose area, softening a strong jawline, creating a new hairline or contouring the cheekbones.

As the saying goes, practice makes perfect! When it comes to developing your skills as a makeup artist, practical work with designs on paper helps you to visualize your model as a flat canvas. This will help you achieve a more realistic effect.

Practise sketching eyelashes or hair details on blank paper until you're confident of getting your desired impression. Once you're happy, you can add to the face chart and use ink or marker on top of the makeup to avoid smudging away the lines.

BROW DETAILS
Think about the shape of the brows you want: whether straight, round, arched, thick and bushy, or thin and sharp. Map out the outline of the shape and detail in light pencil, using an eraser to clean up any mistakes.

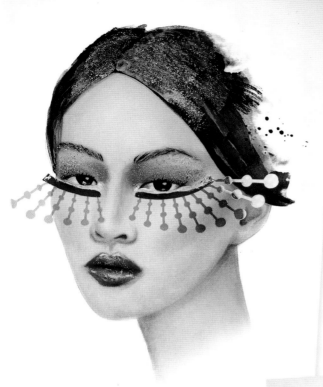

* Powder-based makeup such as eyeshadow, blusher, bronzer and face powder is easier to blend on paper. Creams or liquids tend to be blotchy and leave oil stains if not applied in even layers.

* For a clean overall finish, avoid colour smudging on the white of the eye and use an eraser to remove mistakes.

* On the eye, use smaller brushes for more control over precise colour placement and blending.

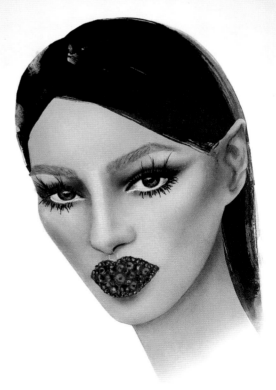

* A thin coat of clear nail polish is useful for protecting the white of the eyes and sealing any creamy pencil or liner to avoid smudging. It can also be used to add shine for a realistic effect.

* A great substitute for eyeliner, to give the impression of liquid liner, is a Sharpie pen or ink pen.

* For super-sharp lines, use angled eyeliner brushes or a pointed pencil brush shape.

* Blend and smudge lines with cotton buds.

* To protect face charts once complete, use artists' fixing spray or a fine dusting of hairspray to stop the looks from smudging.

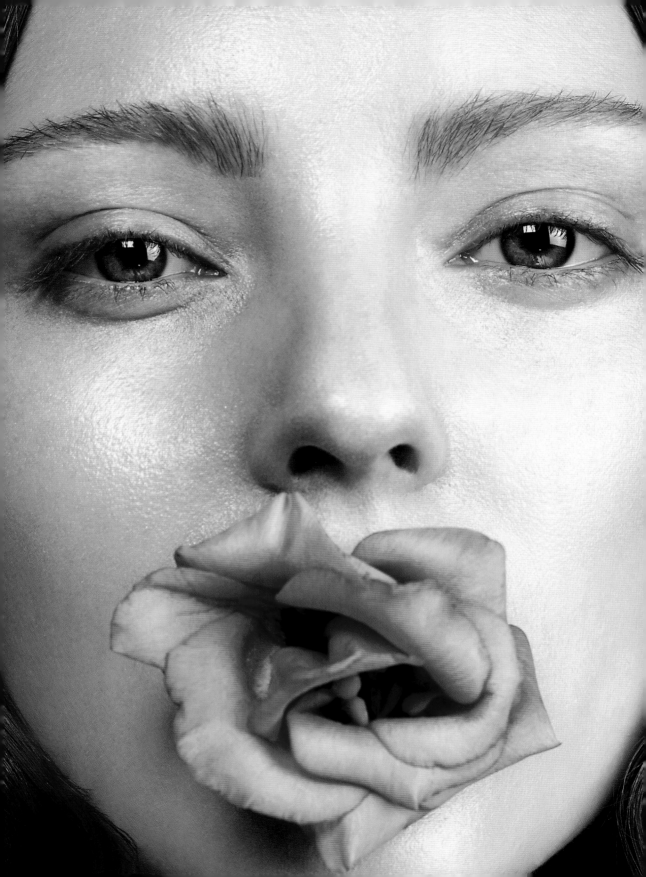

CLEAN

The face is a makeup artist's blank canvas, and designing a look always starts with the skin. It seems like a simple idea, but good skin work is the fundamental base of any makeup look, and it can be considered a look in itself. At the heart of the design are considerations such as skin tone, skin type and the overall finish – whether shiny or matte, raw or dewy, textured or flat.

The foundation we use is the most important part of priming skin to create the perfect canvas. Prepping the skin is a key skill that is quite different to applying makeup, and it needs careful consideration. Skincare products such as moisturisers, creams and serums will add dewiness to the skin, and massaging the face can produce a healthy glow. Other tricks such as primers, to correct either colour or texture, and instant active facials can be used before the makeup is applied.

The face charts at the back of this book already have a smooth base colour, so it's easier for you to concentrate on the actual design process, developing fun ideas and getting creative.

KEY KIT

- FOUNDATION
- CONCEALER
- POWDER
- COTTON BUDS
- SPONGE
- TISSUE
- BLENDER

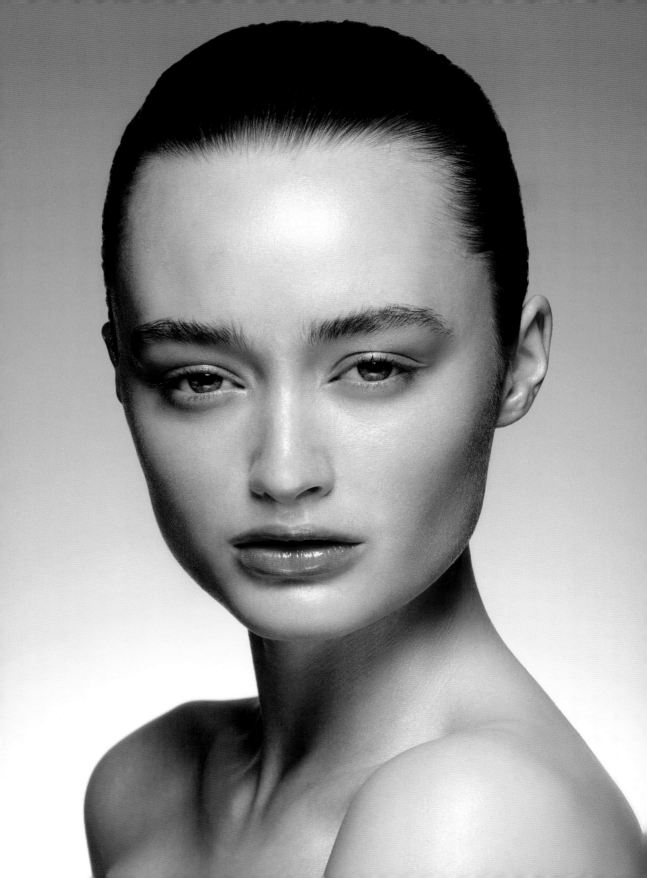

BARE ESSENTIALS

The skin becomes magnified under the photographer's lens, and it's better to get it right with makeup rather than rely on digital retouching, or 'airbrushing', in Photoshop later. You shouldn't be able to see the foundation itself, it should just look like great skin.

Prepping the skin by massaging it with moisturiser increases blood flow and it makes the complexion look healthier and smoother, allowing it to glow.

Sometimes a photographer may request that there is no foundation applied to the skin, as they prefer to be able to retouch it themselves to achieve the best real-skin finish. Maybe there's only the odd spot or blemish that isn't worth covering with foundation, so a simple moisturiser or highlighter can be enough.

Remember that if you try to cover everything and add too many layers to the skin it can cake, so when it comes to retouching the end result can be flat, lifeless skin.

NEARLY NAKED

To create this barely-there look I used concealer sparingly to cover imperfections and set it with a powder to keep the base in place – translucent is suitable for all skin tones – or use skin coloured to match the complexion. To finish I brushed the eyebrows to neaten and applied a natural gloss to the lip.

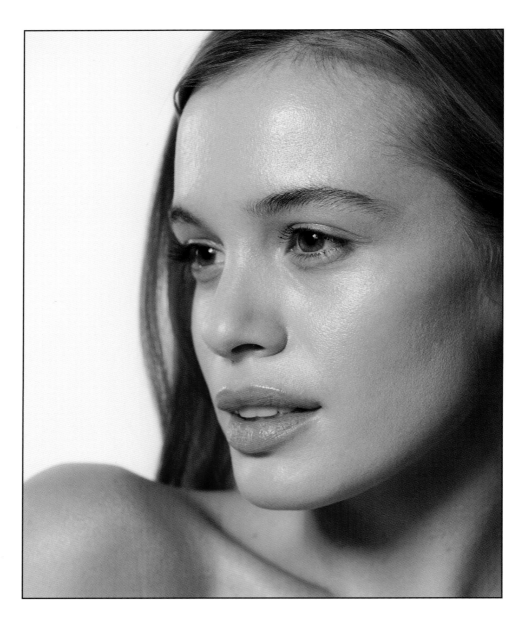

SHINE ON

Every face is beautiful in different ways, and it's great to work with models of all face shapes and skin tones. Subtle variations in highlighting and contouring produce natural looks that vary between minimal, dewy and polished. Celebrate skin!

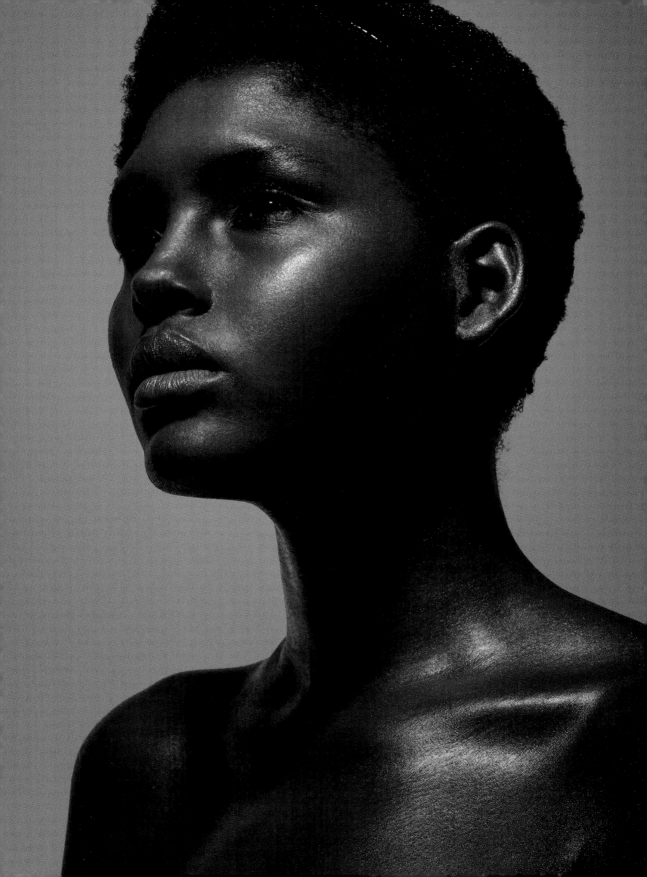

PRETTY PERFECT

Knowing how to achieve a universally 'pretty' look is a key skill for any makeup artist. What makes something pretty, though? There are a few basic elements that can be agreed on. A healthy glow is usually considered appealing – so a rosy flush is added to the cheeks. Symmetrical features have been regarded as the beauty ideal since ancient times, and the correct application of highlight and contour can help balance the face. With makeup we can create the appearance of flawless skin: evening out skin tone and disguising spots, sun damage, broken veins and other so-called imperfections.

ENGLISH ROSE

This is a naturally pretty look, as opposed to a more made-up look. I achieved this by using sheer formulations and pared-back application, adding colour to the apple of the cheek to mimic a natural blush. The effect is completed with full lips and glossy hair.

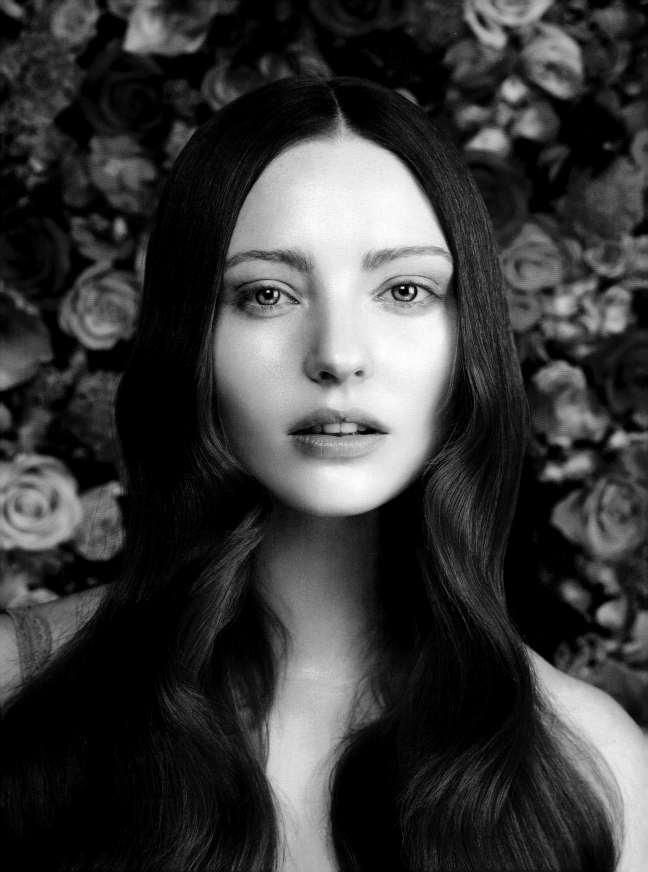

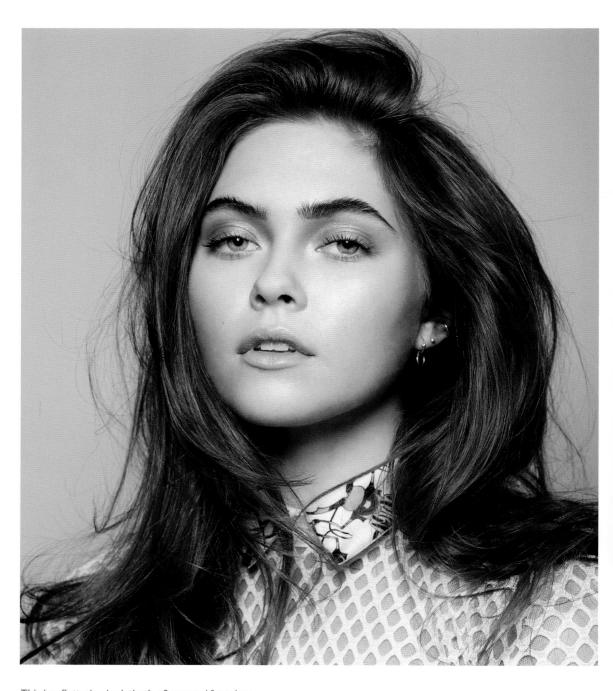

This is a flattering look that's often used for talent, in portraits and for TV. Strong, defined brows are youthful and give the face structure. I enhanced the cheekbones by highlighting the area above, and contouring below with a shade darker than the skin. Contouring around the eyes adds depth, as well as allowing the eye colour to 'pop' slightly. Pale colours will help lips appear fuller.

CLASSICAL

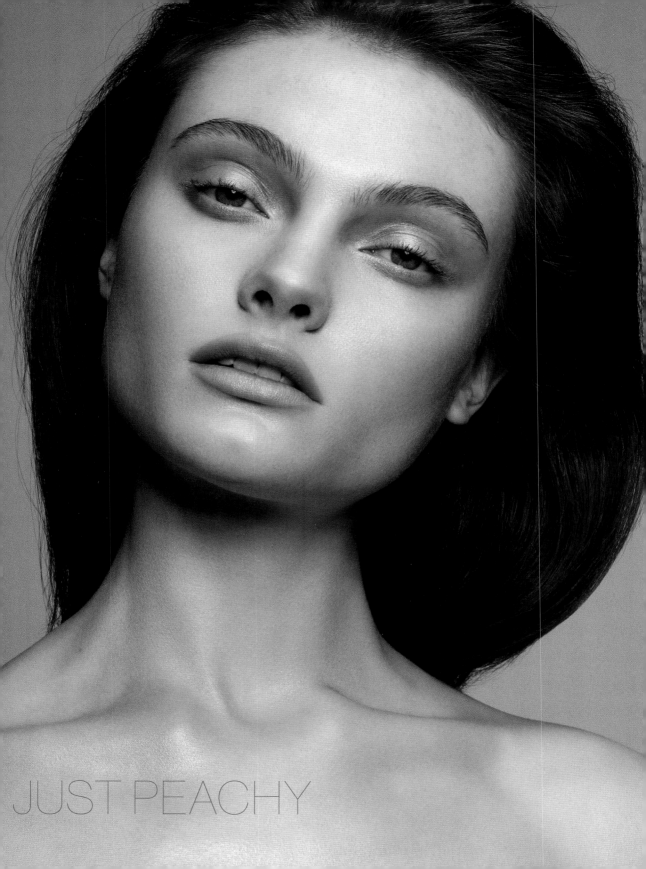

JUST PEACHY

THE PERFECT BACKDROP

Once you have mastered perfect skin you can use it as part of a wider editorial concept. Clean skin can be used as a background to show off a dramatic feature such as shockingly coloured hair or to showcase jewellery, accessories or other embellishments. Creating skin that looks flawless under the lens will ensure you're always in demand as a makeup artist, and will save a photographer hours of retouching.

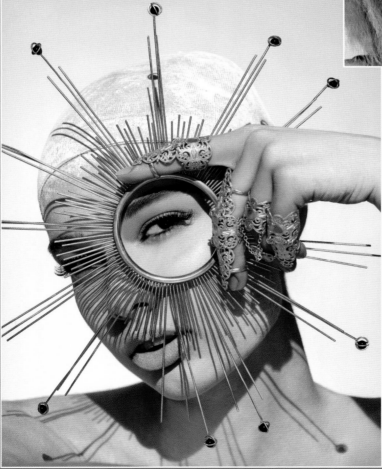

MATTE

In these images the models' complexions are made flat and otherworldly, with the lip colour blocked out so they are pale and matte. It gives the models a futuristic edge that sets off the blue hair and elaborate jewellery.

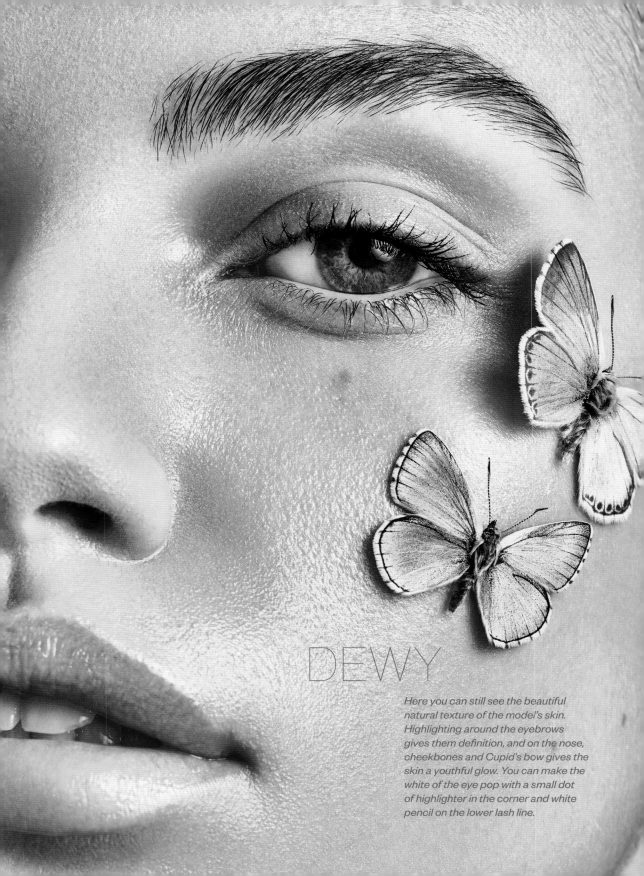

DEWY

Here you can still see the beautiful natural texture of the model's skin. Highlighting around the eyebrows gives them definition, and on the nose, cheekbones and Cupid's bow gives the skin a youthful glow. You can make the white of the eye pop with a small dot of highlighter in the corner and white pencil on the lower lash line.

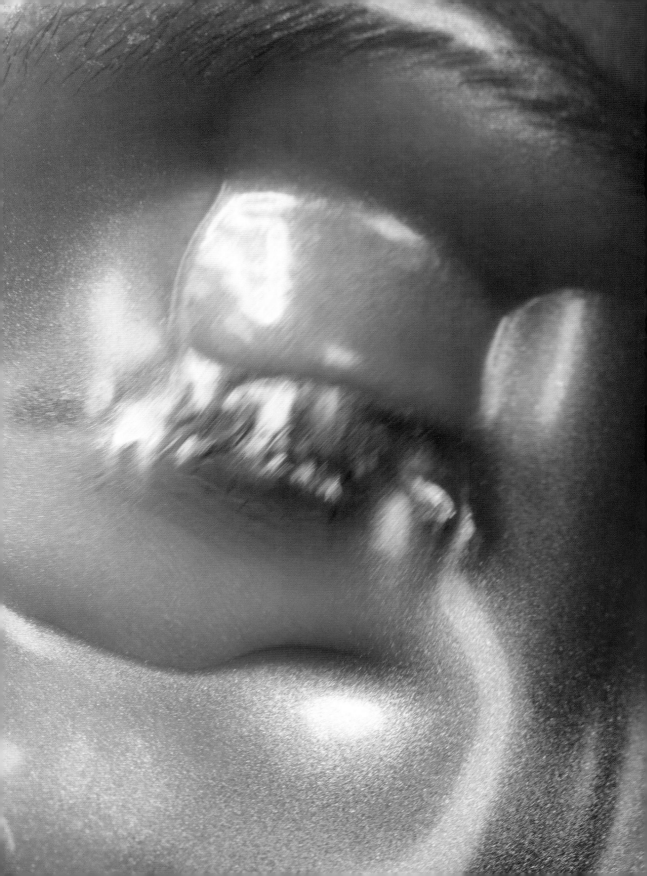

SHINE

Glitter, metallic pigments and highlighters give maximum shine, appearing reflective from all angles and shimmering in the light. They transcend eras, from retro, such as '80s disco, to modern or futuristic characters. Glitter comes in all shapes and sizes, and has become a recurring seasonal trend – from festivals in the summer through to Christmas party bling. Needless to say, glitter needs delicate handling, it's hard to get rid of and you can still be finding it months later! There are many biodegradable glitters available these days.

Other gleaming textures, such as holographic powders, have a micro-fine powder texture for a subtle shine. Real gold leaf gives a more solid, crinkly effect and has become a trend on the catwalk, in shoots and on the red carpet. Anything that's reflective can be used, even cut-up foil or metal tape. While some of these looks aren't exactly day wear, they do make striking artistic images and are fun for a photographer to experiment with lighting effects on the model.

Vaseline or other balms such as Elizabeth Arden Eight Hour Cream, Egyptian Magic or Paw Paw cream provide a skin-friendly base for the glitter particles to stick to. Glue stick can be used to create harder-edged shapes, or to block out the eyebrows. For vast areas use body glue or more Vaseline, and for irregular and sporadic placement simply blow the glitter all over.

KEY KIT
- GLITTER
- METALLIC PIGMENTS
- HIGHLIGHTER
- GOLD LEAF
- MASKING TAPE
- EYELASH GLUE
- GLUE STICK

SUBTLE SHEEN

A wash of highlighter over the whole face will give a pearlescent lustre to the skin. Highlighter comes in many forms, from satin powder to cream gloss or pencil. Highlighter liquids can be mixed with foundation to give a luminous sheen, or pure highlighter can be thinned with water to give a sheer effect or cover larger areas of skin. Iridescent skin is beautiful when seen close up, as in this editorial shot, is suitable for a fashion magazine editorial without overpowering the image, and would also work on the runway to mirror the delicate feel of a designer's collection.

SHEER DELIGHT

This skin-based look is paired with pastel-toned eyes of mint green, lilac and sky blue. The overall effect feels very spring/summer, and has the delicate look of a watercolour painting. The model's skin has been kept purposefully raw so you can see the natural texture of the skin. Highlighter emphasizes any blemishes or imperfections, so casting a model with good skin becomes extra important.

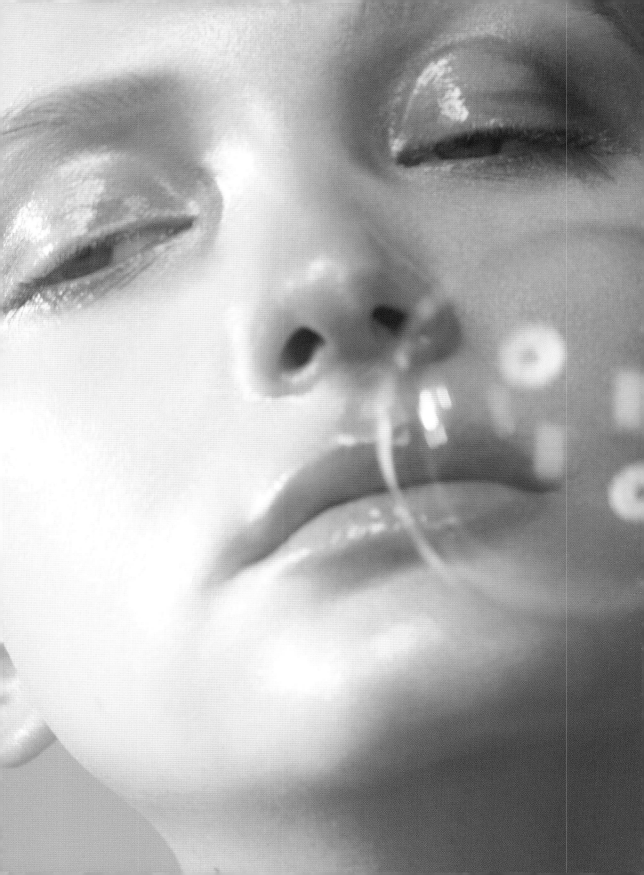

LET THE LIGHT IN

You can use shimmering highlighter powders and metallic tones on the face and body to achieve a range of looks, whether a dusting of silver to give an ethereal glow, subtle daubs for a glitzy party look, or heavily pigmented blocks of colour for a more artistic feel. Consider what kind of lighting will work best with your makeup: soft and diffused, leaving minimal shadows, or hard and directional, leaving distinct areas of light and shade. Whether you are shooting with natural daylight or in the studio will also play a huge part in the look of the final image.

This was inspired by the heavily powdered faces of Elizabethan ladies, which I updated by creating a graphic triangle shape from above the eyebrows to below the mouth in a pearly finish. I used a stencil technique, mapping out the area first and then stippling the powder on to the face using a flat-bottomed brush.

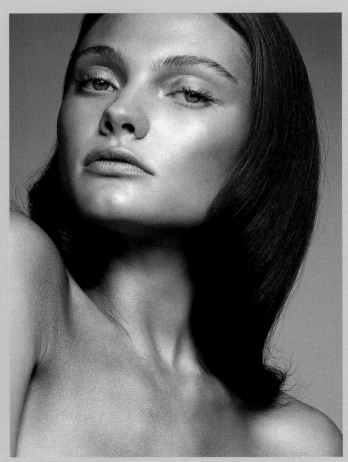

MULTI-TONAL

You can use one bold accent colour, but here I mixed several together from a palette for multi-dimensional shine.

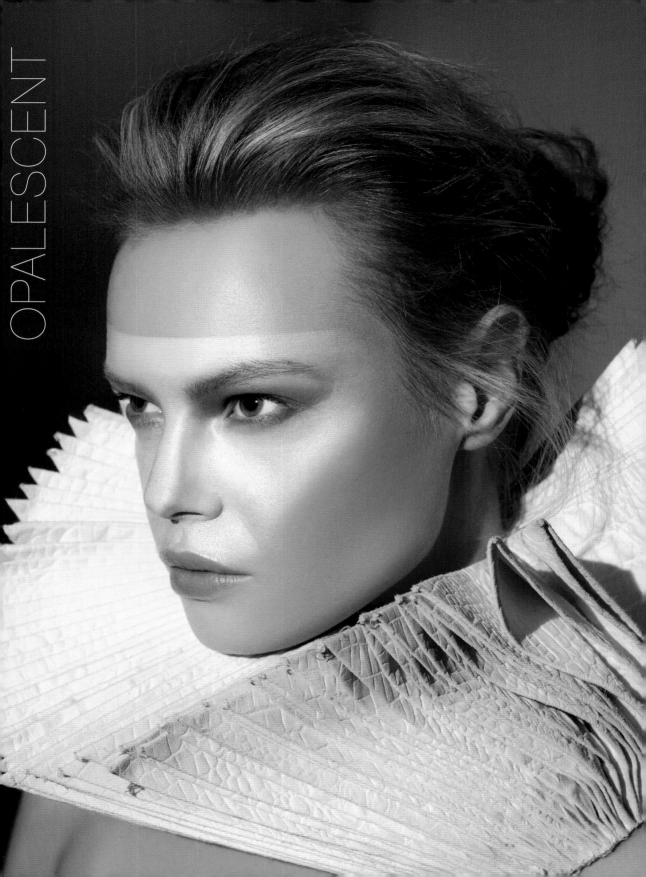

OPALESCENT

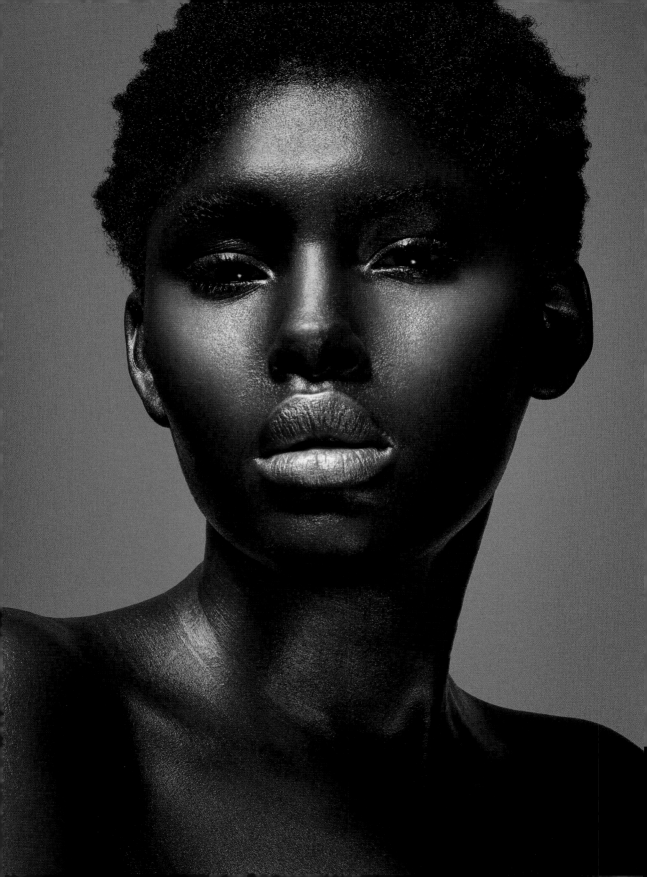

METALLIC

Darker skin tones work beautifully with bright gold shades. Here, I worked several layers of gold powder into the skin with a firm, round brush, fading it towards the eye line to create an ombre effect. You can offset metallics with bright pops of colour, such as hot-pink blusher, and layer over colour to give a unique finish. This copper-over-tangerine lip really jumps off the page. Note how the lighting here is more directional, sitting above and slightly to the front of the model.

DISCO EYES

This rainbow mirrorball look was created using glitter. The circle area around the eye was given a base of greasepaint, so the glitter sticks to it automatically. I dabbed the glitter on firmly using a flat brush, and gently removed any excess with a soft, light blending brush before cleaning up the edges with tape. Don't restrict yourself to just gold and silver – coloured glitter adds a beautiful dimension to any look.

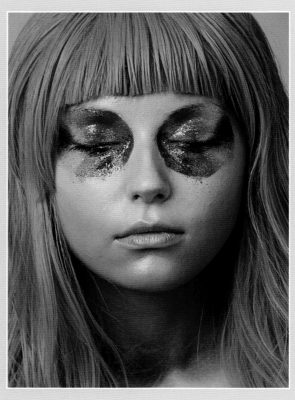

GLITTERBALL

Removing glitter can be time-consuming, so always carry tape in your kit: masking tape is gentler on the skin than ordinary sticky tape. Simply pick it up in small, quick motions. Kitchen roll, or a rolled-up towel, is good for dusting off any remnants.

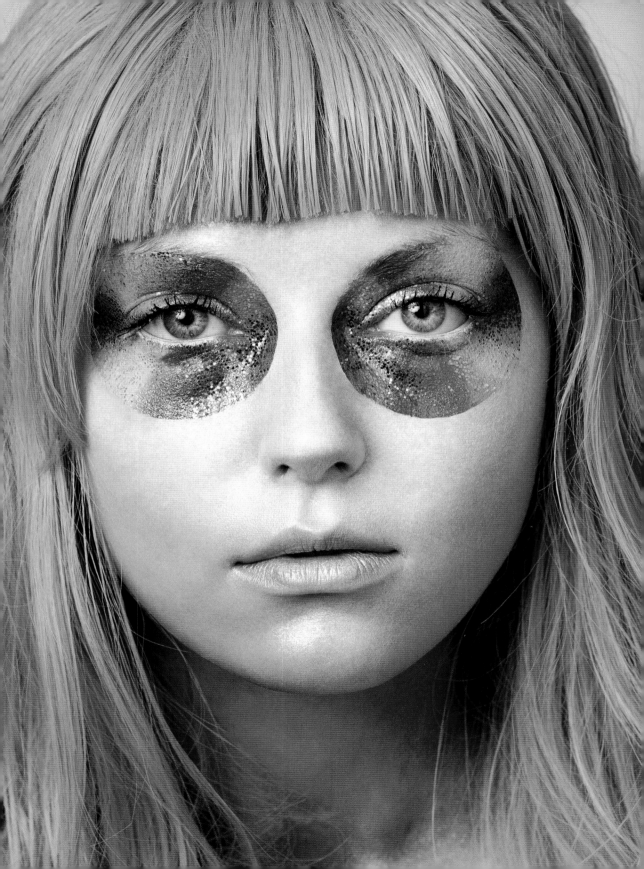

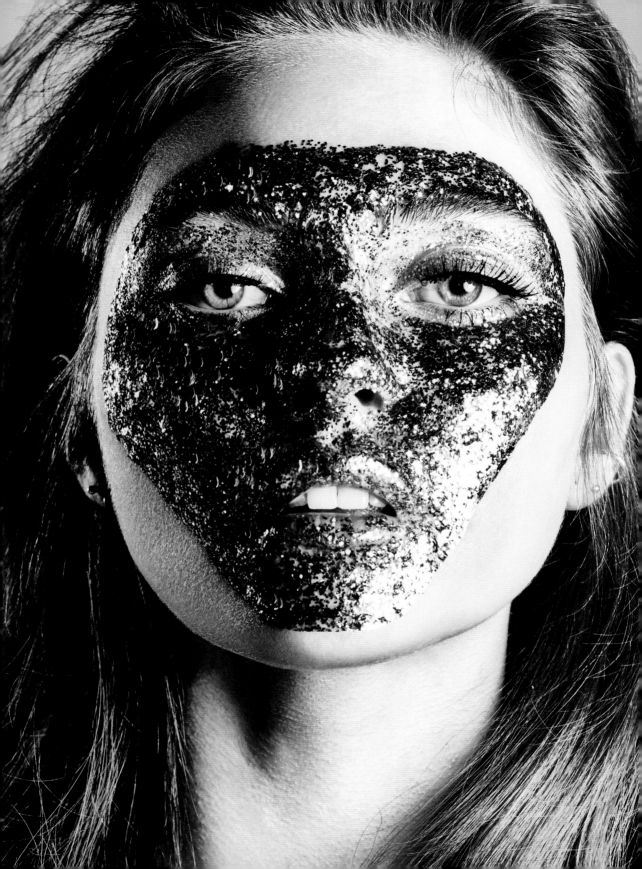

HEAVY METAL

What could be more dramatic than adding gold leaf to your makeup? Real gold leaf is kinder to the skin than the artificial sheets as it is naturally hypoallergenic, especially the higher carat weights, which have a larger metal content. Use long sheets for maximum coverage, or cover smaller surfaces with pieces broken off.

Using gold can play a huge part in the art direction of an image. When photographed in black and white, the viewer's eye is focused on the contrasting areas of highlight and shadow rather than being distracted by the colour, as seen in the glittery gold mask on the left. In the image below, I made a base for the gold leaf to stick to with Vaseline and applied it by holding it with tweezers – the heat of your hand would activate the gold leaf – and using a soft brush to sweep it on to the base.

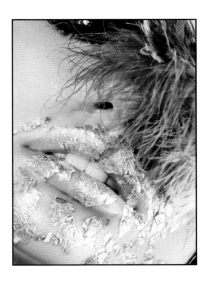

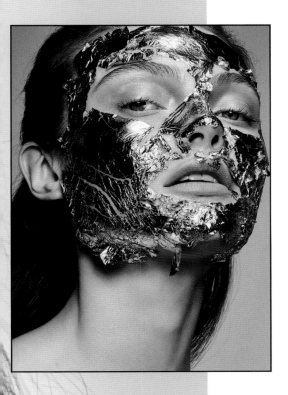

Contrasting textures make for a rich photograph. Above, the luxurious metal sits alongside a plume of feathers and grungy, oil-slick eyelids. The edges of the gold leaf can be buffed to a smooth finish, or left purposefully raw and distressed. Small pieces can be fixed in place more firmly with a dab of eyelash glue.

TEXTURE

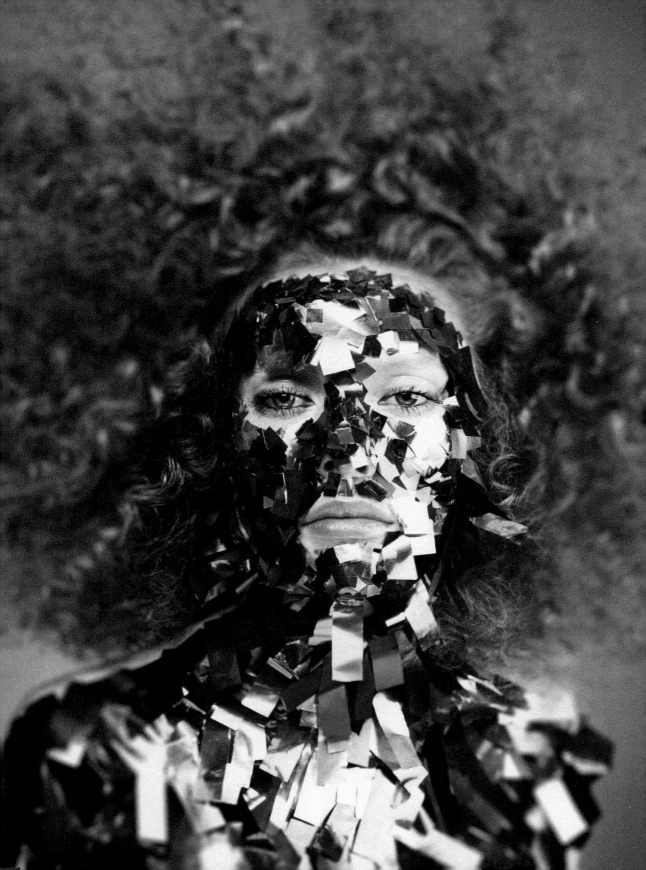

GOT IT TAPED!

Really push the boundaries and create an extreme look using foil tape embellishments – these larger reflective pieces will add a whole new dimension to your creative look. Pre-cut several lengths of the metallic tape, from small squares to long rectangles, and keep them close by. The key to this look is patience and a delicate touch to stick the pieces of metallic foil paper to the skin using eyelash glue or body glue.

Simply dip a brush in eyelash glue and create a pattern of dots on the skin, mapping out where you want to place the tape, and then stick the foil where the glue is. Repeat the steps until you have full coverage. Sometimes it's the simplest idea that has the most impact!

SHINY FOIL

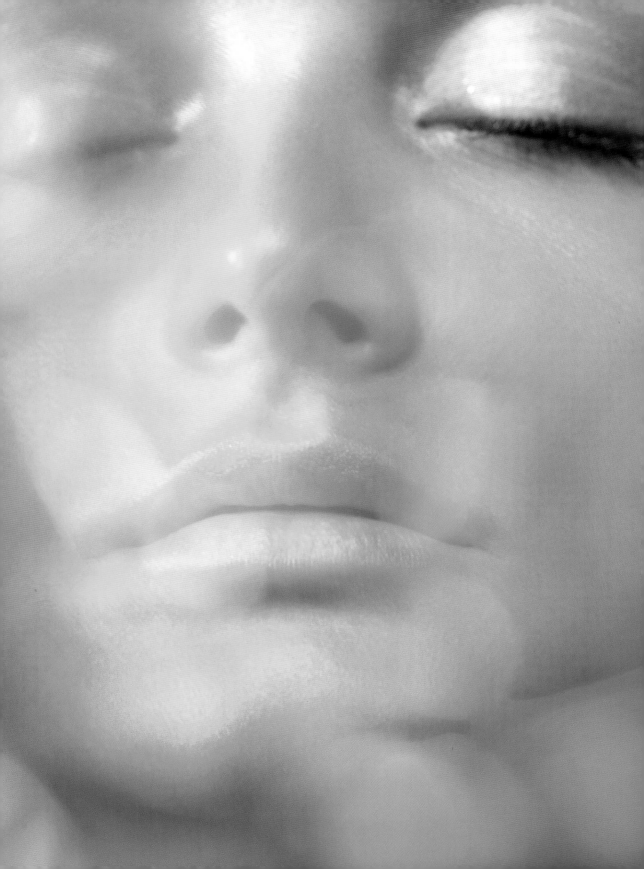

PAINT

The fundamental rule when working with colour is to understand colour-wheel theory and harmony – which colours bring out the best in each other. Red and pink sit opposite green, purple is across from yellow, and blue from orange, so these are complementary colours, and used together they can produce dramatic effects. There are many other concepts for harmonizing shades, such as analogous colours, which sit next to each other on the colour wheel and create a balanced look when used together.

With so many colours and formulations available, it's almost impossible not to achieve any shade you want. Begin with the correct skin-tone foundation, then add complementary colours to enhance the features. Complementary colours can also be used for colour-correcting – experiment with mixing cool and warm tones for the perfect base. Adding yellow to the skin can give it a healthy glow, and orange and blue enhance the hues in both primary and complementary colours.

Lighting will affect how colours appear, so it's important to bear this in mind when designing a look. The more light there is on a model, the more washed-out the makeup will look. Light adds shadow and contrast, which will affect the perceived depth. Using gels (transparent plastic sheets in different colours) over the studio lamps will add extra colour to the look and can change tones, making some colours disappear altogether. Shades and in-between tones are especially important for black-and-white photographs. Variations in texture, such as cream, powder shimmer or pure shine, will make colours appear different, and they will gain more depth from blending well in a palette.

KEY KIT

- SOFT BRUSHES IN VARIOUS SIZES
- SPONGES
- FACE PAINT
- BODY PAINT
- EYESHADOWS

COLOUR CRAZY

Recreate the feel of an artist's studio with Jackson Pollock-like splashes using all the colours of the rainbow. When two complementary colours sit next to each other they create a strongly contrasting effect, but when they are mixed together they can produce a dirty grey tone. The looks shown here are more purely conceptual beauty looks rather than catwalk or fashion editorial – all that messy paint would understandably make any stylist nervous!

Why not let the model get creative too? Below, the model was invited to use her hands to get the random and impressionistic placement of colour on her face.

FINGERPAINT

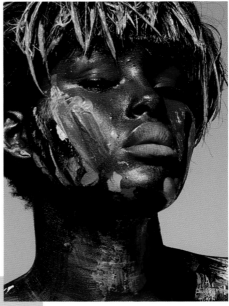

CANDY COLOUR

You can even paint without paint – I used coloured chocolate buttons, melted down to the consistency of paint. I then applied them to the skin using my fingers and blended them using the melting effect of a hairdryer! In the image opposite I used the same technique with my fingers, working quickly to get the 'paint' to mix.

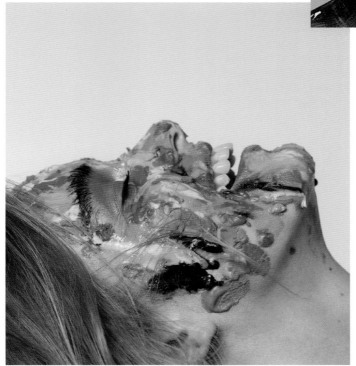

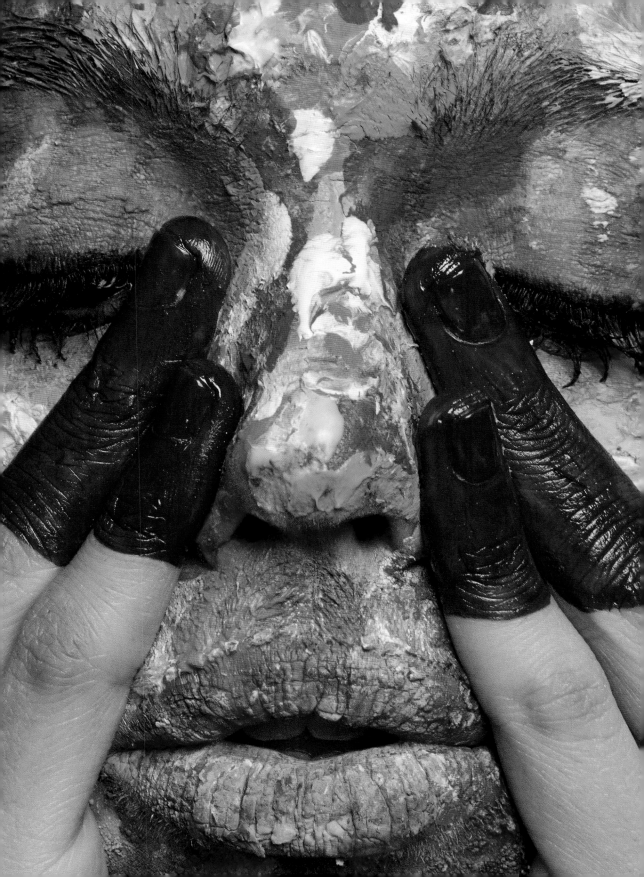

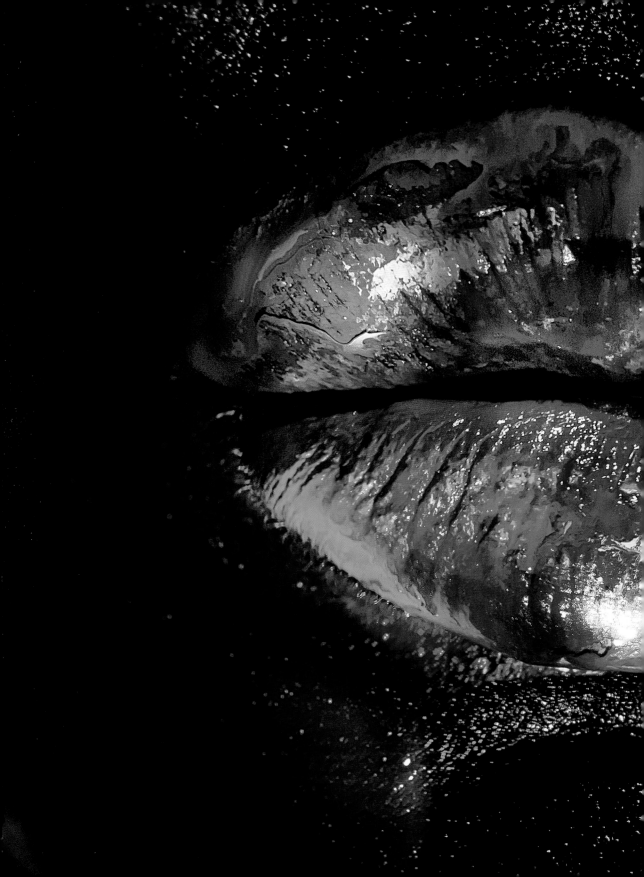

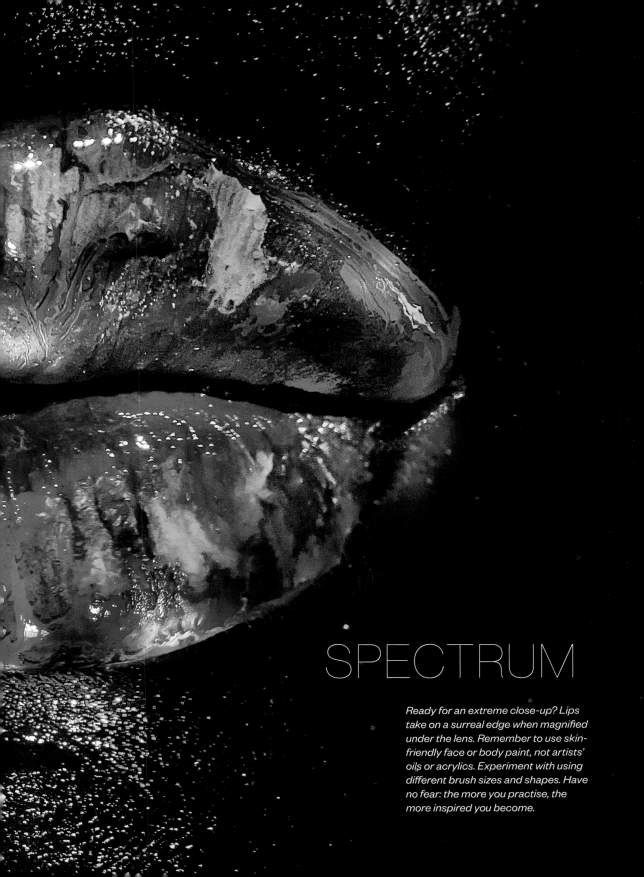

SPECTRUM

Ready for an extreme close-up? Lips take on a surreal edge when magnified under the lens. Remember to use skin-friendly face or body paint, not artists' oils or acrylics. Experiment with using different brush sizes and shapes. Have no fear: the more you practise, the more inspired you become.

BLOCK PARTY

Blocking out the face with a limited palette of colours, say two or three, can produce dramatic looks and effects. The face can be divided up geometrically into planes, or you can pick out different features. Creating a makeup look is not just about the colour itself, but the transparency and depth you want to achieve. For example, a wash of colour gives a softer effect, while a thick, solid application of paint gives a bold, three-dimensional effect.

TRICOLOUR

This image is a riot of primary colours with yellow on the cheeks, red on the chin and blue on the hair. To make the colours really pop I first used a white base and applied the colours on top, carefully blending where they joined.

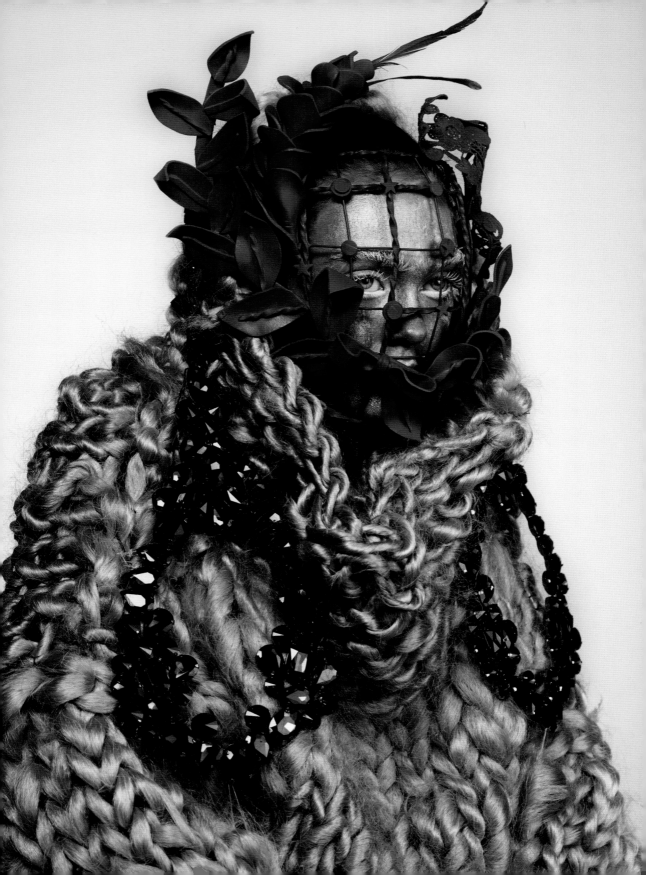

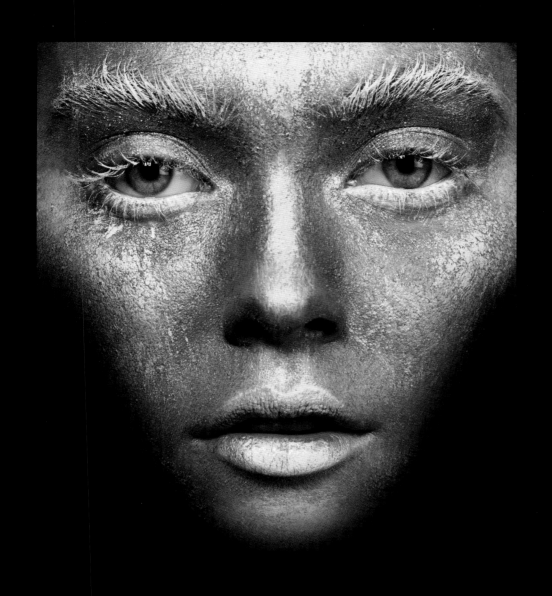

PURPLE HAZE

Contouring and highlighting with colour helps to create illusions in character makeup looks. I applied the purple base with a sponge, and then picked out the features in thick white paint to give a wintry, 'Snow Queen' effect. Remember to start with thin layers of paint and add thicker brushstrokes over the top.

LESS IS MORE

Accentuating one feature will give a more pared-back, wearable look while allowing a single colour to really pop. This look is often seen on the catwalk, when the makeup artist takes inspiration from the colours in a designer's collection, either complementing or contrasting them. The details of the rest of the face become important to create a flawless background. Leaving the lashes bare and brows natural will create different moods.

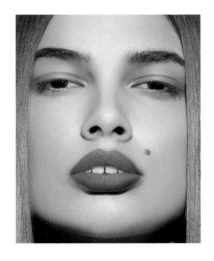

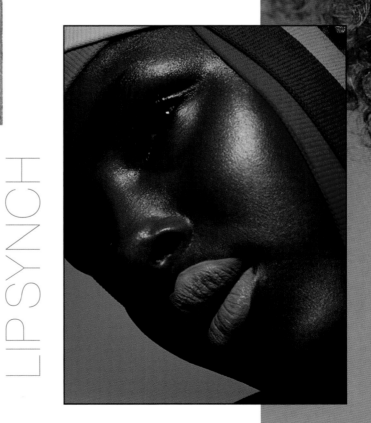

LIP SYNCH

A bold lip is an easy way to play with colour and still make a statement. Nothing helps to pull a look together like a classic red lip – choose a shade of red with a blue undertone to make skin look brighter and teeth whiter – and an unusual colour can instantly update a look.

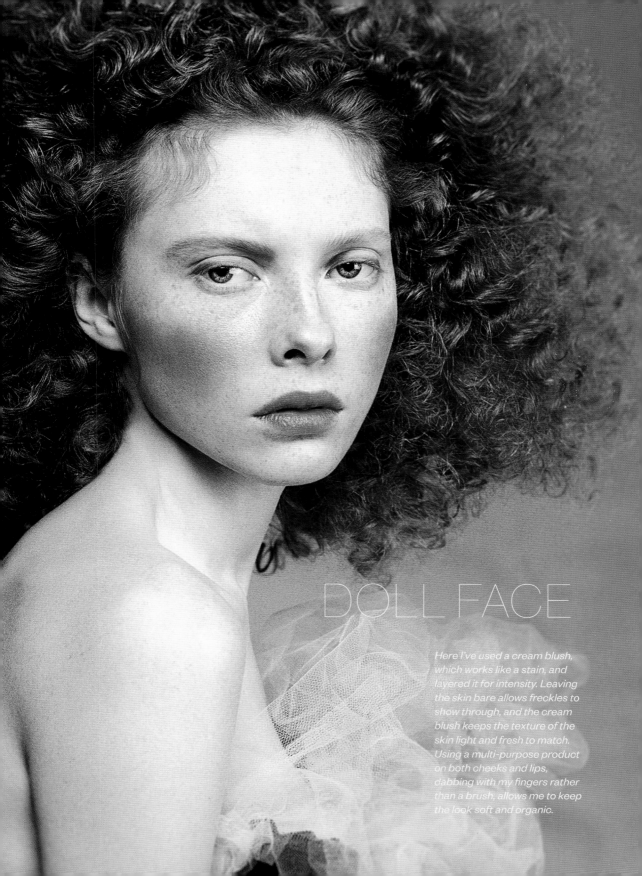

DOLL FACE

Here I've used a cream blush, which works like a stain, and layered it for intensity. Leaving the skin bare allows freckles to show through, and the cream blush keeps the texture of the skin light and fresh to match. Using a multi-purpose product on both cheeks and lips, dabbing with my fingers rather than a brush, allows me to keep the look soft and organic.

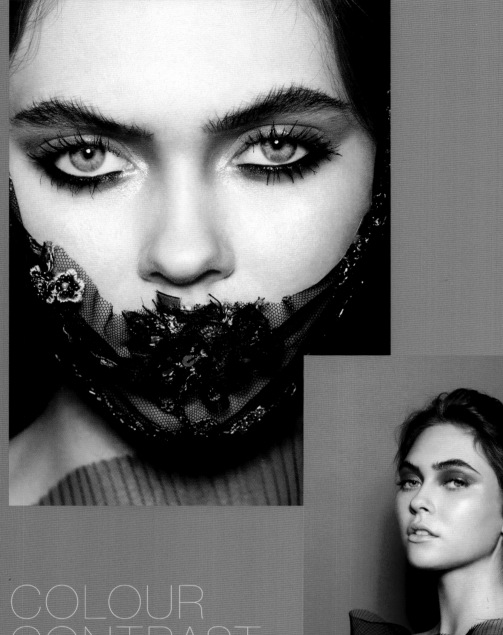

COLOUR
CONTRAST

*Practise mixing eyeshadow
colours using cool and warm tones.
Complementary colours on the wheel
will bring out different eye colours: it's
the reason blue eyeshadow often looks
better on brown eyes rather than blue.*

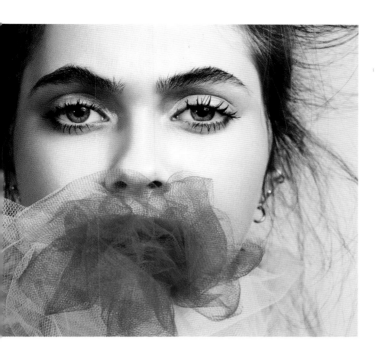

IN THE PINK

Washes of a single accent colour travelling from the eyes and spreading on to the cheekbones can highlight and contour, without you having to add any other colours. Pay attention to the depth of tone and colour placement, from heavier shading in the sockets to softer washes towards the hair line, elongating the contours of the face.

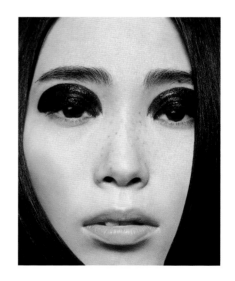

BOLD LOOKS

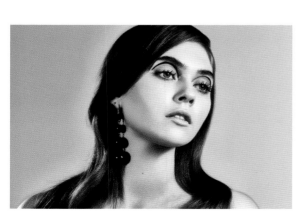

Solid shapes on the eyes can transport you to an iconic era of fashion such as the 1960s. This black half-moon shape follows the socket line and is most pronounced above the centre of the eye. You can also simply use a graphic line in the socket. Having a solid block of colour can be raw and edgy, but by changing the colour or base formula you can create myriad effects.

MORE IS MORE!

Some makeup artists say that you should never try to enhance all of the features at the same time, but for a purely artistic look where the resulting photograph has the feel of a painting, throw away the rule book and paint all features with all colours for an overdose of maximalism! The effect can be outlandish and clown-like, or pretty and impressionistic, depending on the tones and contrasts.

I applied soft washes of colour with blending brushes, using light strokes to create this even, delicate look around the eyes. The face is framed by contrasting black lines for the eyebrows and paint strokes on the neck, which give a harder edge, matching the dense block of dark colour on the hat.

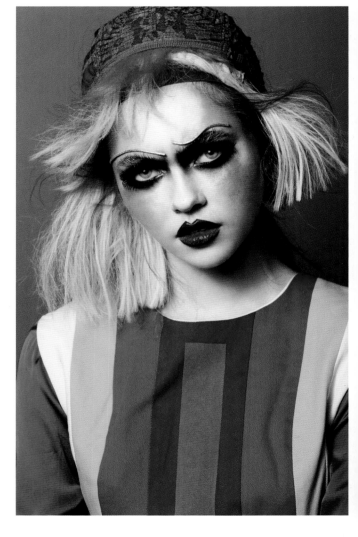

COLOUR OVERLOAD

This look was fun to create! It was inspired by a coloured smoky eye – as the colours blended I played around with texture to start creating a character. I gave the look an edge with a luxurious, sharply-defined, dark velvet lip, with thick pieces of thread for the eyebrows to give them a hard expression. Always consider your model's bone structure first – this can look like overkill if you haven't taken into account the rest of the features such as the nose and jawline.

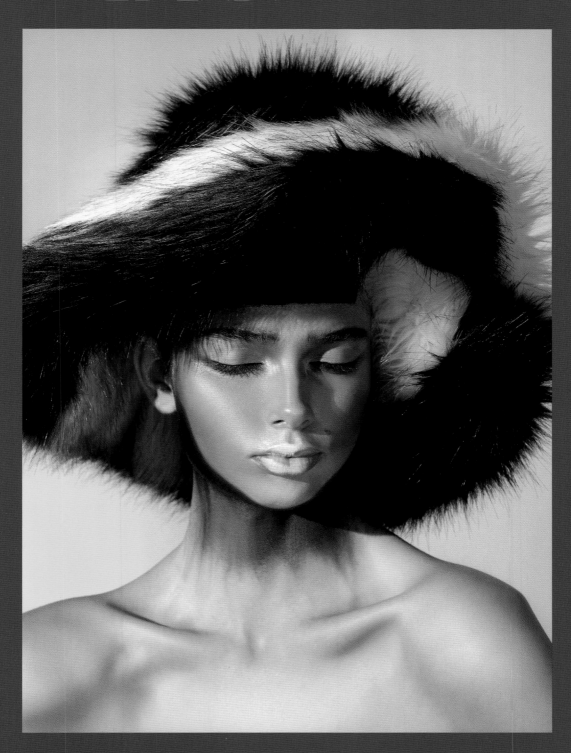

COLOUR CONTRAST

You can transform one look into another to provide an interesting before-and-after effect in a beauty story, plus it makes the most of your shoot time. A canvas of clean, pure colour acts as the base – the paint is thinned down slightly with water for ease of coverage, and applied with a sponge and brush. The art direction of the second image, a multi-coloured painted warrior, is much darker – both in terms of its lighting, the model's mood and the colour of the paint.

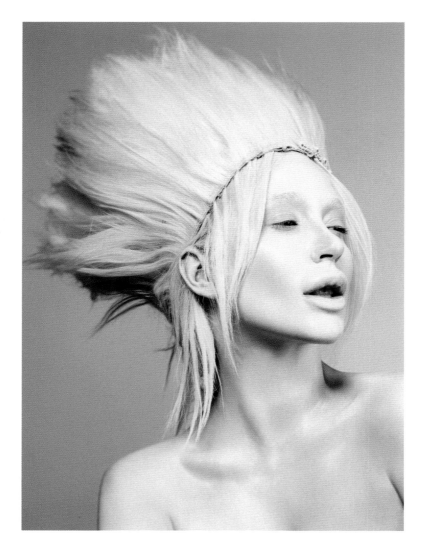

A blank canvas is not always as it seems. Varying textures of off-white will give skin a porcelain finish in the light. I love mixing white-cream with highlighters, and using different paint textures to give a multi-dimensional finish. To the eye it looks like one shade of paint, but on camera the light reflects and bounces back from the highlighting cream and pigment shimmers used on the bone areas.

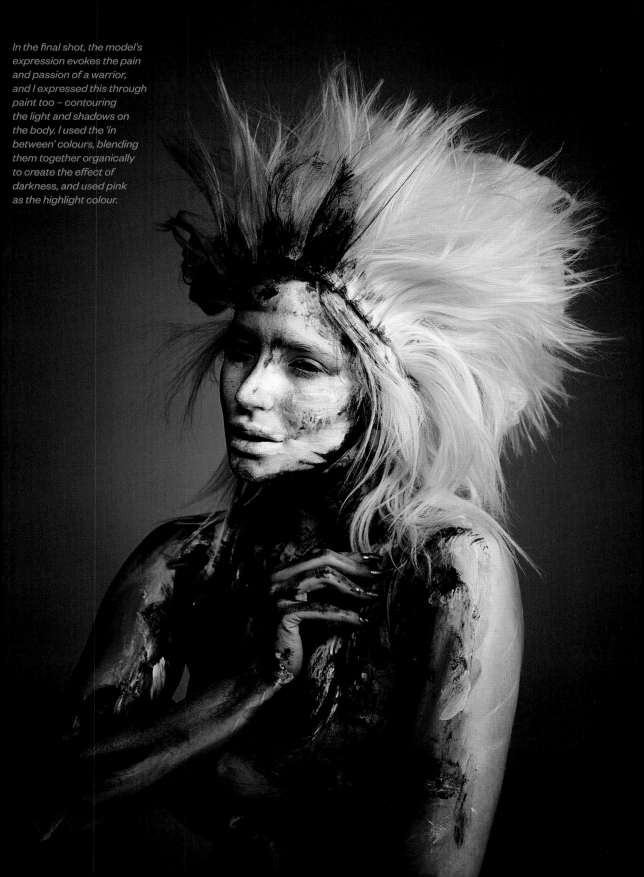

In the final shot, the model's expression evokes the pain and passion of a warrior, and I expressed this through paint too – contouring the light and shadows on the body. I used the 'in between' colours, blending them together organically to create the effect of darkness, and used pink as the highlight colour.

THROUGH THE LOOKING-GLASS

Who said the paint has to be on the model?
You can play with colour and paint in other
ways, daubing it on to plastic or glass sheeting
that's either transparent or tinted. It opens up
the possibility of using other art materials, such
as oil, acrylic or spray paint. Shooting through
a glass prism can add interesting effects too,
splitting the light into a spectrum of colours.

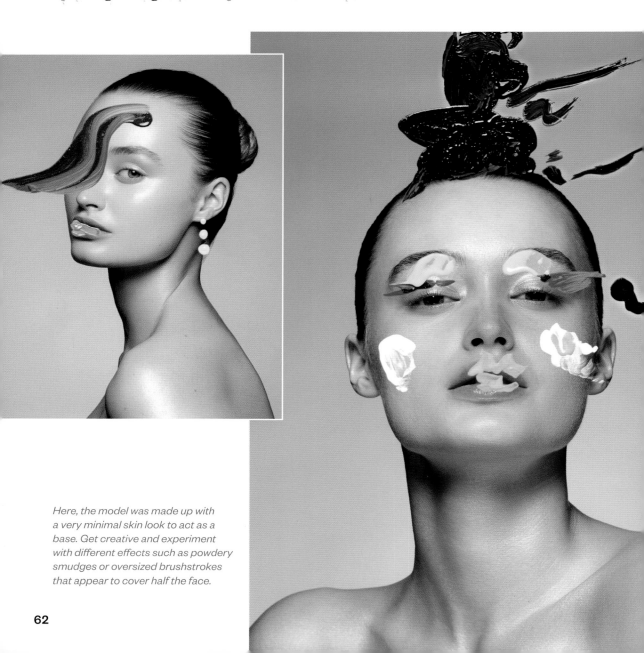

*Here, the model was made up with
a very minimal skin look to act as a
base. Get creative and experiment
with different effects such as powdery
smudges or oversized brushstrokes
that appear to cover half the face.*

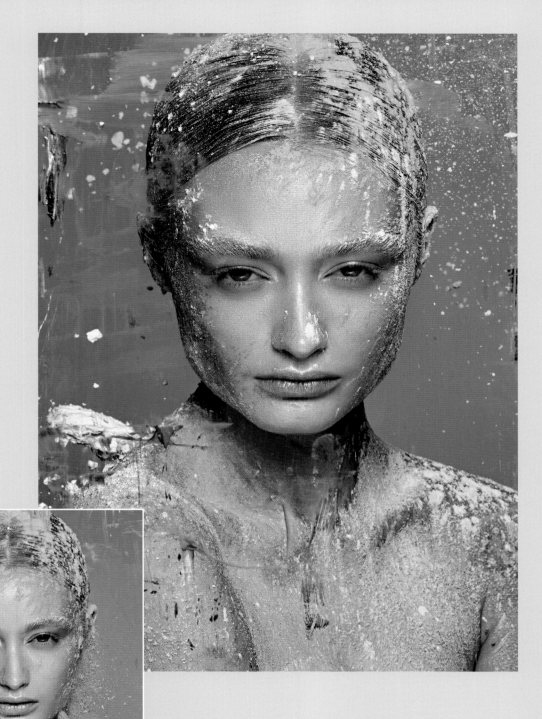

POWDER &
PAINT

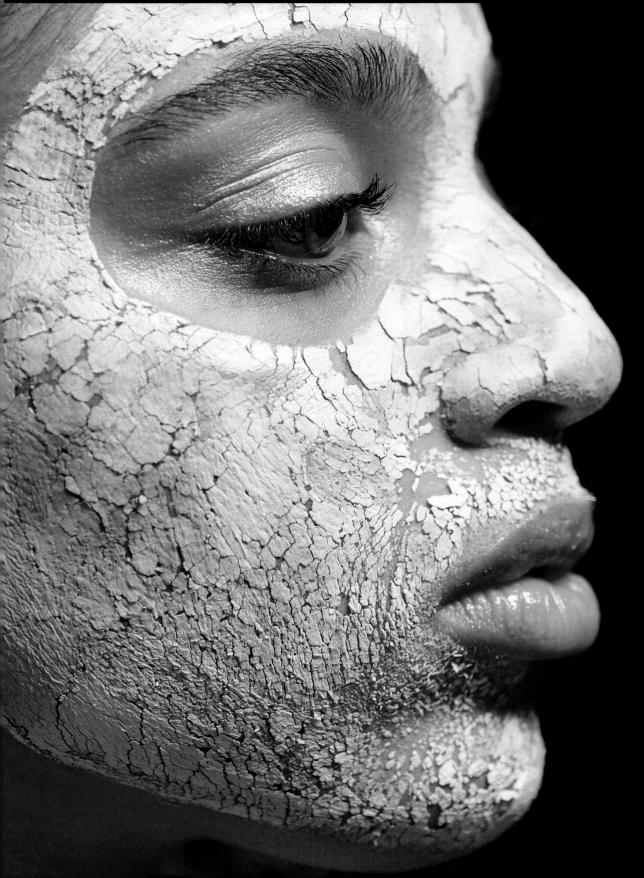

TEXTURE

Texture in makeup is vital in creating the literal feel of a look. Whether matte or shiny, smooth or cracked, the composition of the makeup will add an extra dimension. Textures such as jelly or balm are more recent technical innovations as cosmetic formulas have developed, and are now regulars alongside metallic shine, glitter, velvety matte, glossy shine and shimmery pigment finishes. As these textures will add an extra level of playfulness at the design stage, your artistic impression on the face chart will become a memorable end look.

As makeup trends change from season to season, variations in texture can be seen. We often see gloss finishes for spring/summer and dry, powdery effects for autumn/winter. The texture of makeup also has a huge effect on fashion photography – reflective materials add shine, while a dull or lustreless surface will absorb light.

Think outside the box with extreme textures such as edibles, flowers and leaves, gold leaf – anything that can stick to the face! Other sources of texture such as skincare formulations, face masks and honey can all be used to create a striking image. Eyeshadow in particular has many textures to play with: matte, satin, frosted, metallic, iridescent, cream and mineral.

KEY KIT

- FALSE LASHES
- FEATHERS
- SCISSORS
- FABRICS
- EYELASH GLUE
- TWEEZERS

CRACKING UP

As clay face masks dry they create a distressed texture, breaking apart to reveal fragments of smooth skin beneath. Face masks come in a variety of different colours and can be used as a base for layering paint. Experiment with different effects – mixing a dash of colour into areas of the wet mask and letting it dry, or letting the mask dry and dusting over a shot of pigment powder. Remember, with this kind of mask, the more the model moves their face, the more the mask will crumble away. Check how long the mask manufacturer advises leaving the product on for, to avoid over-drying the skin.

FACE PACK

Keep in mind that the medium you use becomes like an extra layer of skin, so when using colour it needs to be in the right place to highlight or contour in order to flatter the model. In this image, pink is used to highlight and blue to give the impression of shadow. The colour was added after the mask was dry, using eyeshadow.

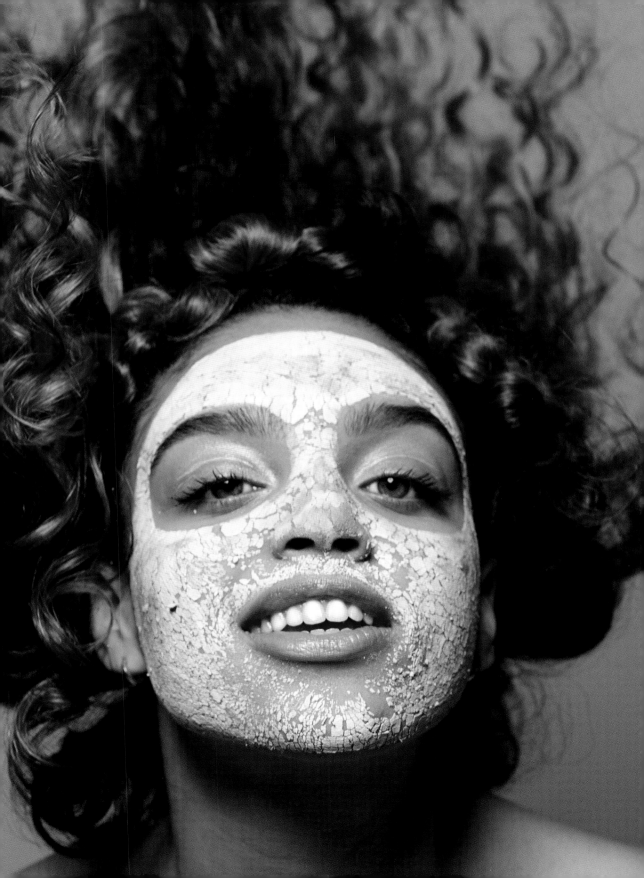

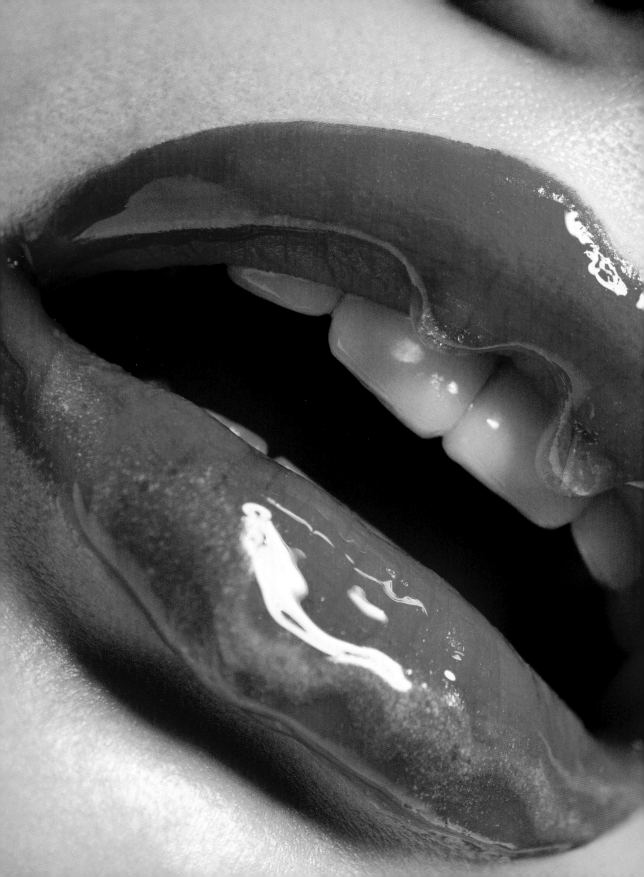

GET LIPPY

Beautiful, full lips are the perfect canvas for a variety of textured looks. When viewed close up, lips take on a surrealist quality like Man Ray's painting *The Lovers*, or Salvador Dalí's famous Mae West Lips sofa. My ongoing series of lip art has been shown in several exhibitions and is always one of the most talked-about aspects of my work. Before starting your look, prep the lips by exfoliating and moisturising to ensure a smooth canvas.

Here I used a combination of food dye and lip gloss. I wanted to see how the dye would move on the glassy substrate. Interestingly, it didn't blend easily and held its place well, creating this shimmery, iridescent effect.

FOOD COLOURING

PETALS

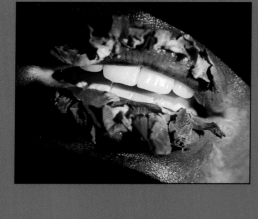

Dried, velvety rose petals give a romantic, naturalistic feel. The rose petals here were edible and the base colour was a lip stain.

JUICY

Keep layering on the gloss for a juicy, wet-look effect.

BLACK GOLD

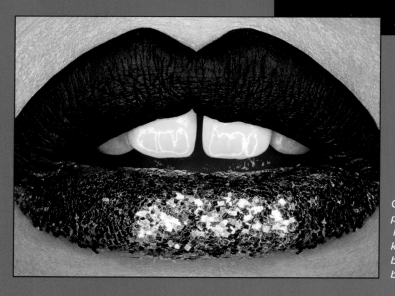

Glitter looks striking when paired with a matte finish. I drew the outline with black kohl liner, then layered over black lipstick, finishing with black eyeshadow powder.

Pucker up! Letting a mask dry over the edges of the lips creates interesting ridges in the skin. Extra paint or airbrushing will add depth and dimension.

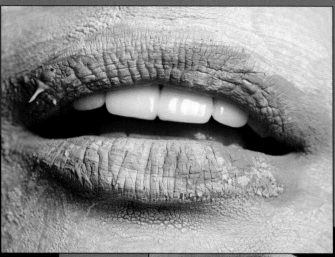

SPLOTCH

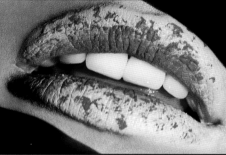

Matte over matte using contrasting colours creates a flat, artisan effect. I used different sized brushes and the foam tip of a brush applicator to get the variations of dots and bleeds of colour.

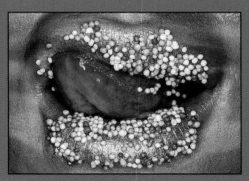

Candy sprinkles are a fun and non-toxic medium to play with. I blended the undercoat with greasepaint, which provides an adhesive layer for the candy.

CANDY CRUSH

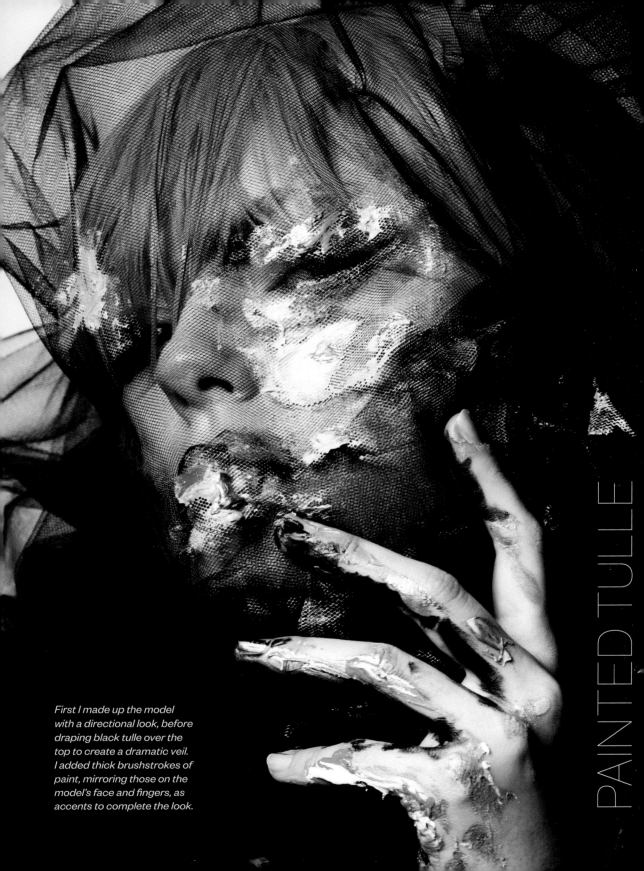

First I made up the model with a directional look, before draping black tulle over the top to create a dramatic veil. I added thick brushstrokes of paint, mirroring those on the model's face and fingers, as accents to complete the look.

PAINTED TULLE

BENEATH THE VEIL

Netting or lace can be applied on top of makeup to add texture to a look. Experiment with using different kinds of fabric such as tulle, which has tiny holes, fishnet, which has large holes, and cobweb-style netting, which has a spooky, cracked appearance. Netting can either be pulled tight to the face, or sculpted into a veil or visor shape. Try painting over netting to create a secondary canvas above the skin. Netting can also be used as a base to fix a variety of decorations such as artificial birds, butterflies and ribbons.

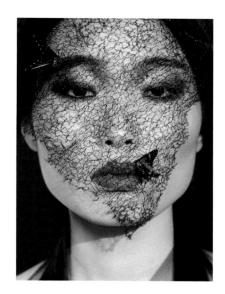

NET
RESULT

The haphazard fibres of this cracked-effect netting creates interesting shapes across the model's face. And look! A moth and a butterfly appear to have landed on her lip and eyebrow. These were specialist dried insect specimens sourced from butterfly farms, where they died of natural causes before being collected. You can find similar sustainable companies online.

FANTAS-EYES

Add drama to your look using feathers, false lashes and fur textures to create variation of depth and mood, which can transform your look from something that is classic and iconic to a fantasy or animalistic character. When shooting editorial, bear in mind that feathers and fur will absorb the light and can be used to contrast with other finishes. On the catwalk, feathers come alive with every step of the model, adding movement to the look.

Individual feathers were cut down and fixed carefully to the eyebrow and lower lash line, one by one, using tweezers and a dot of eyelash glue, to create a dramatic wing look. The hair has been slicked back to act as a contrasting texture.

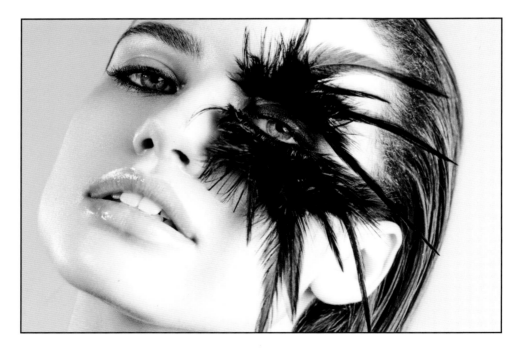

BIRD'S EYE

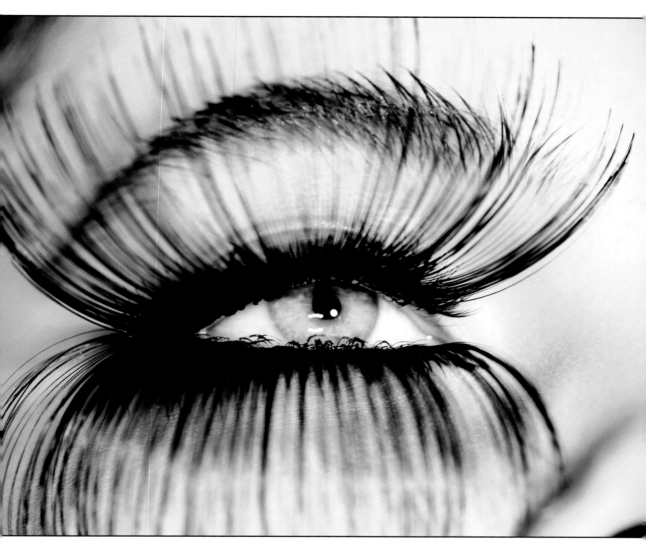

FULL
FLIGHT

Feather lashes are available from many sources these days. They can be trimmed to fit the model's eye shape, and fixed in place with normal eyelash glue. This pair has been attached to the top and bottom lashes to give a fluttery effect.

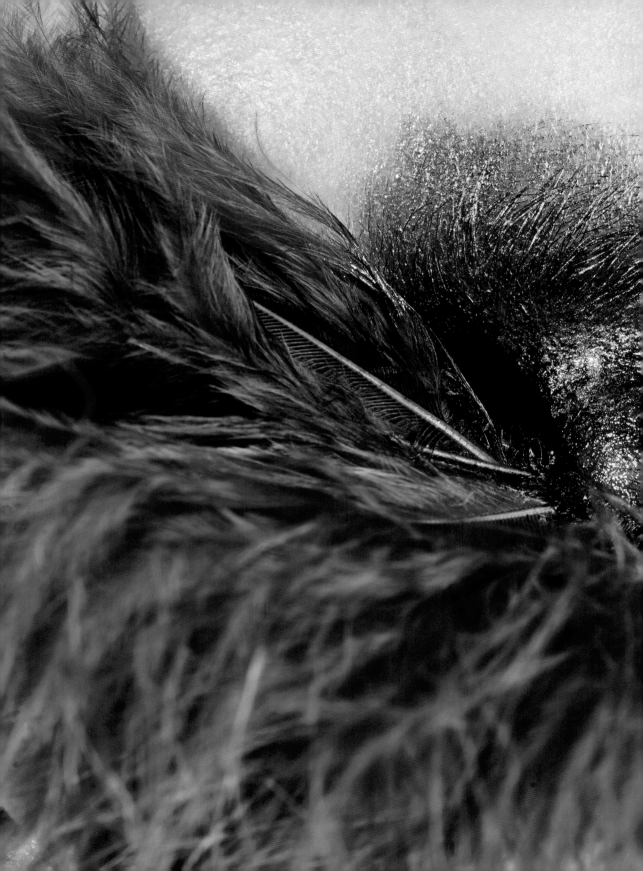

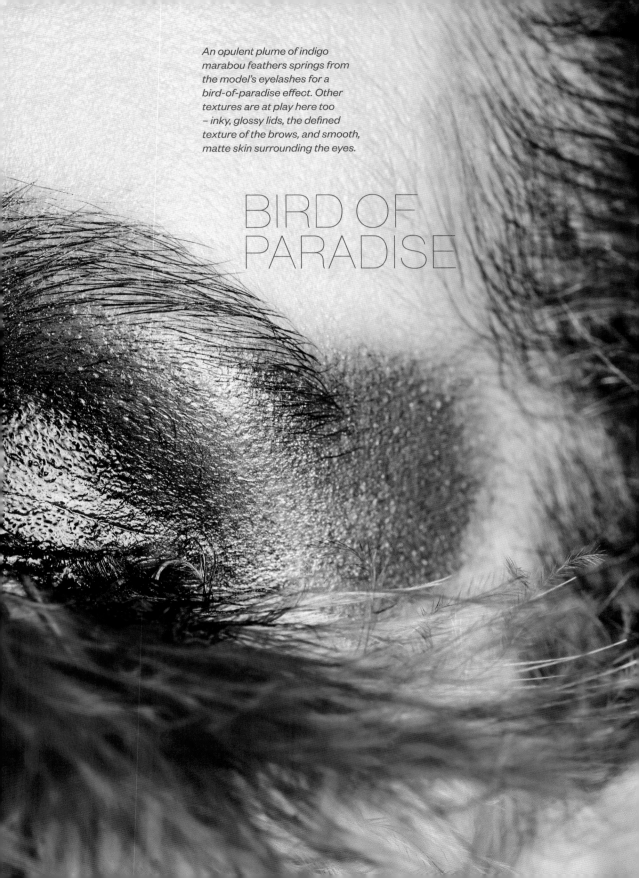

An opulent plume of indigo
marabou feathers springs from
the model's eyelashes for a
bird-of-paradise effect. Other
textures are at play here too
– inky, glossy lids, the defined
texture of the brows, and smooth,
matte skin surrounding the eyes.

BIRD OF
PARADISE

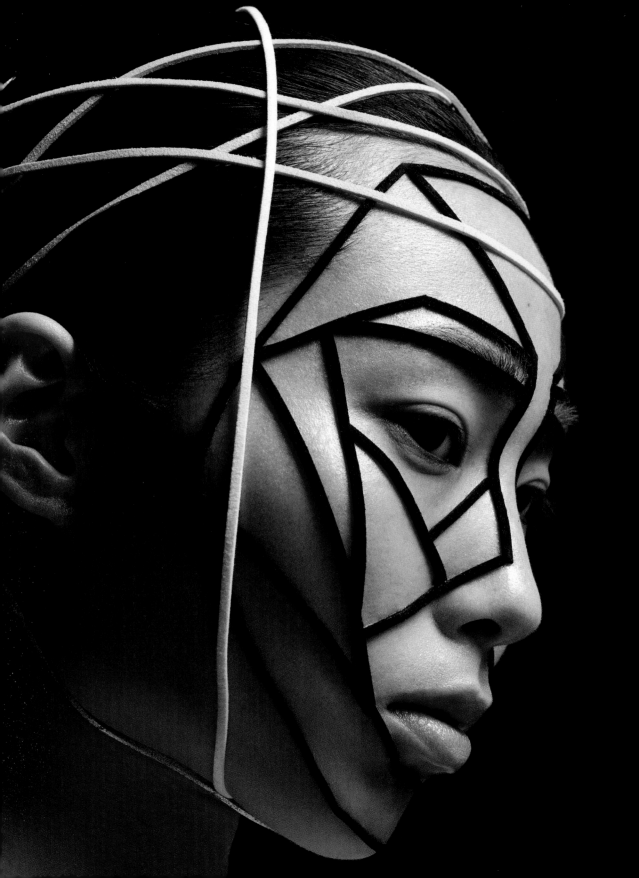

GEOMETRIC

Graphic lines and illustration are key in makeup design for creating shape, drama and character, but can also feel modern and cutting-edge. Simple eyeliner, or winged eyeliner, transcends trends and is important by itself or as part of a look. Remember that the face is contoured, so creating a straight line is not always what it seems! Winged eyeliner can also look very different on different eye shapes, try not to force it to look the same on everyone.

Graphic lines often feature on the catwalk. They evoke classic glamour but give it a contemporary edge, sometimes inspired by the shapes and colours found in defining periods of architecture and the fine arts. Varying lines between hard and soft and bold or faint keeps it interesting and fun and allows nuances in your creative message to be interpreted by the audience. Like a child learning to draw with stick figures and straight lines, there are no rules when designing geometric looks.

Lines create a journey for the eye to follow, and can draw attention to specific areas. Consideration is required, as bold shapes, straight lines and fluid brushstrokes can create illusions, changing face shapes to either perfect or distort the features.

KEY KIT

- EYELINER
- INK OR PAINT
- COTTON BUDS
- PAPER & CARD
- FABRIC & FOAM
- STRING

STRING THEORY

Who knew string could be so useful to a makeup artist? String, tape and ribbon are convenient ways to apply pliable shapes to a model, and come in many colours and textures. Consider the mood of the shoot before deciding what might be the best material, and experiment with delicate strands of cotton thread, raw-edged twine, luxurious ribbon and plastic-covered cord.

Opposite is a more freeform way to apply string, using it to map the contours of the face in an organic fashion. There are more lines and shapes hidden in this image – the eyebrows have become rectangular blocks, and a bold pencil stroke accents the lower lip line.

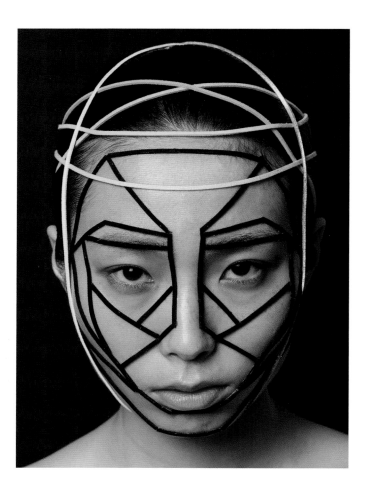

SYMMETRY

Here I applied string in a symmetrical pattern to the planes of the face, with contrasting colours orbiting the crown of the head. The look was perfected first on a face chart, then the black pieces of cord were cut with precision to join up on the model's face. My tip is to use white kohl pencil to dot out where the lines should go before applying the string.

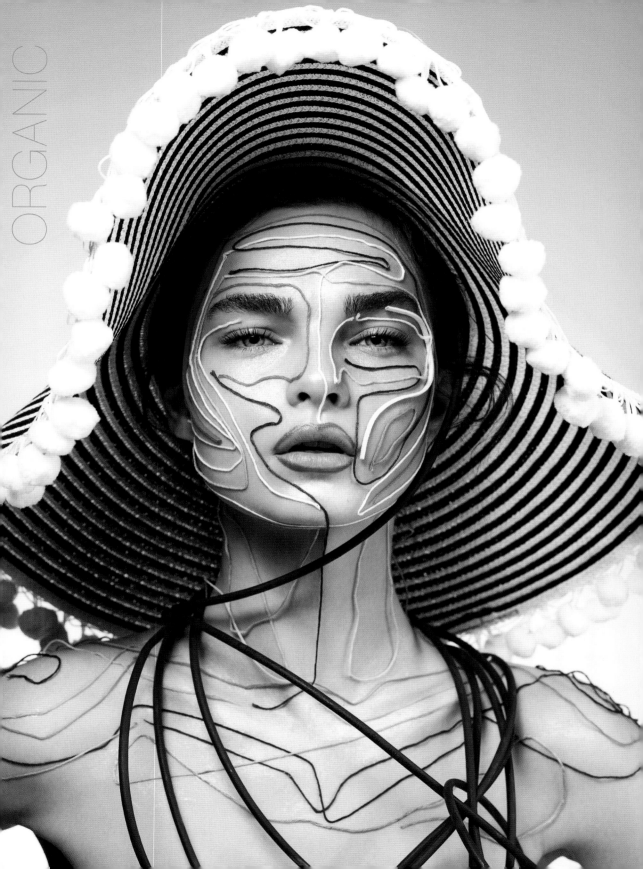

ORGANIC

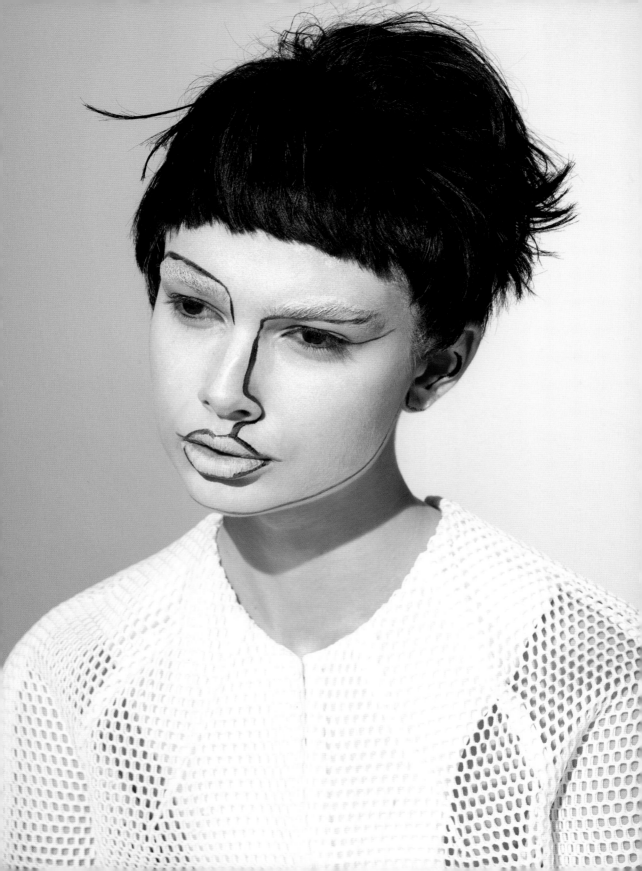

DRAWING
THE LINE

Abstracting and simplifying the facial features in the manner of a modernist line drawing or stylized cartoon will focus the viewer's attention on the areas you pick out. Drawn freehand, no two lines are exactly the same. Variations in the weight and definition of the edges of the line will make it feel handmade and unique. If you're not naturally good at drawing, then take a plain sheet of paper and practise creating straight lines continuously in all directions – fast strokes help to improve confidence. Practice makes perfect!

POP
ART

This two-dimensional look has its roots in work by Pop art icons such as Roy Lichtenstein. Crisp black lines are set against a white base for maximum contrast. The look is far from retro, though, especially when paired with a choppy hairstyle and crisp, modern fashion.

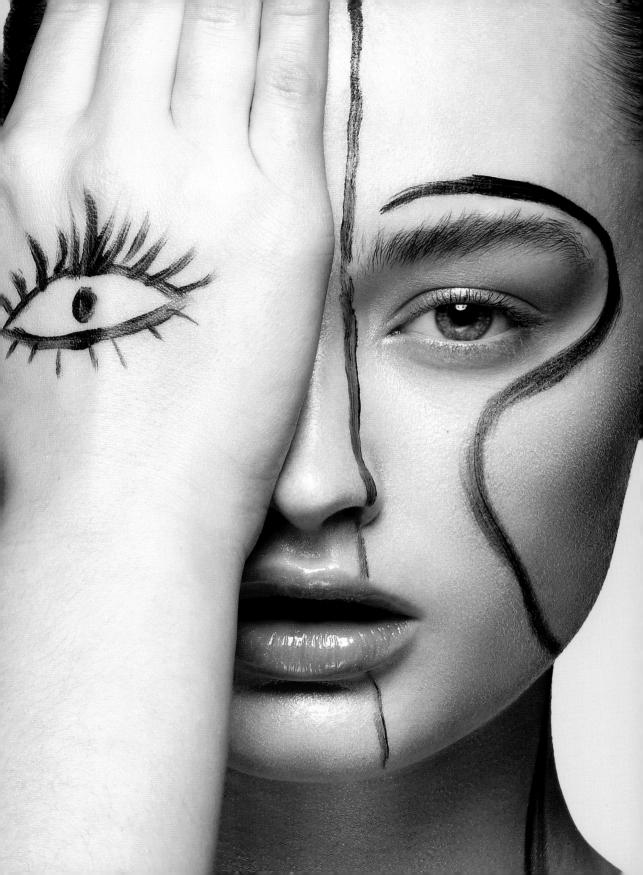

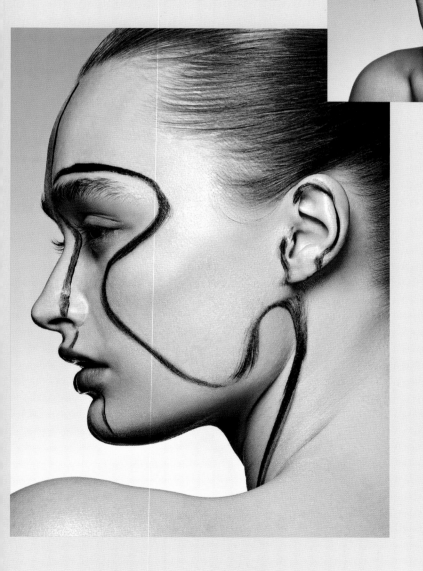

EXPRESSIVE

A powerful result can be achieved with a minimalist approach. Here I just drew two lines on the face freehand, a curved line on the ear and a basic eye motif on the hand. They really jump off the page when paired with a super-natural base. This was a quick and liberating look to create.

MODERN ART

Pablo Picasso was a visionary who moved between several artistic styles during his career, from Cubism and Postmodernism to Surrealism and Neoclassicism. It's a lesson in thinking outside of the box and leading rather than following the pack. Understanding Cubism will help you to analyse a subject (in this case, the model) and reduce forms into basic geometric parts to produce an edgy Picasso-esque look.

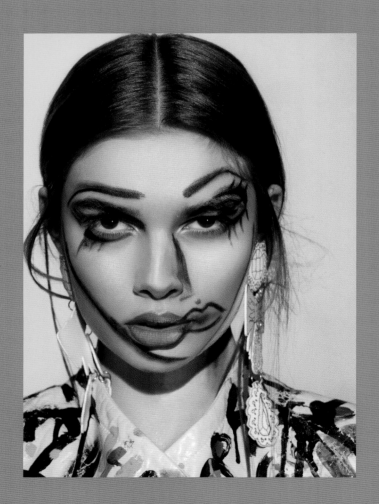

Features have been distorted and exaggerated in both of these images: a highly arched, quizzical eyebrow, the sharp line of the cheekbones, a graphic pout, spiky two-dimensional lashes and an artificial beauty spot. It's a challenge to create a balanced yet intensely asymmetric look.

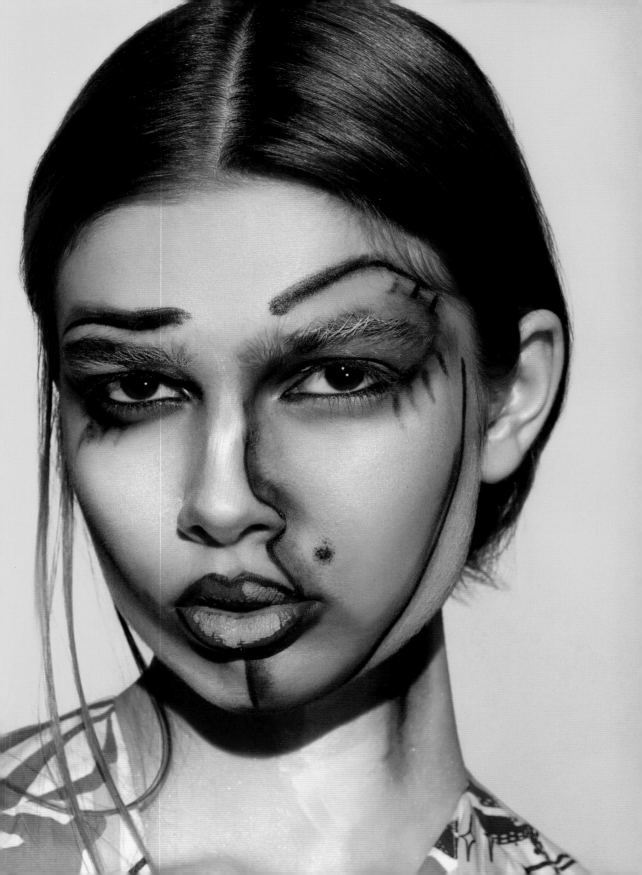

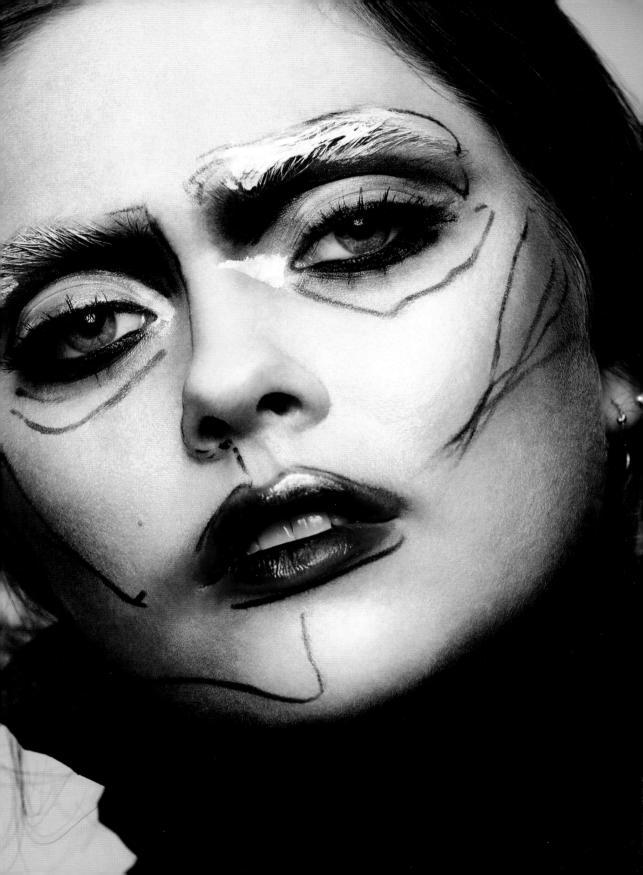

BLURRED LINES

Graphic lines don't always have to be perfect – for a more spontaneous feel to your work, lines can be scribbled and smudged. A huge variety of pencils is available, including kohl eyeliner, lip pencils and chubby sticks. Try warming the colour on the back of your hand first so that it's easier to apply and blend. This is more of a freeform doodle than a precise design, so while it's good to have a basic plan from your face chart, trust your instincts and let your imagination run free.

DOODLE DESIGNS

In art, this is what would be called a mixed-media design as it uses more than one material. In this look you can see black eyeliner pencil and paint layered on in different thicknesses, then deconstructed to create a beautifully fragile effect.

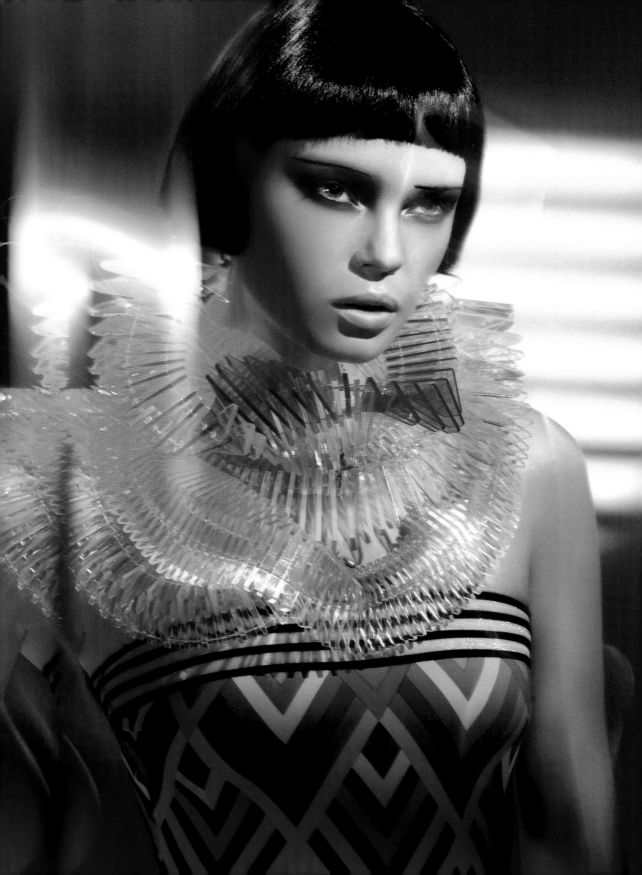

FUTURE PERFECT

Art direction in fashion photography takes into account the mood and feel of the whole image, not just the makeup. You can complete and complement a geometric beauty look with sharply cut futuristic hair, patterned wardrobe styling, laser-cut jewellery, structural set design, linear props, strobe lighting effects and post-production techniques. Sometimes these factors will lead the focus of the shoot, and it is the makeup artist's job to create a look that enhances the work of your creative team.

FORM &
FASHION

Neo-noir is a contemporary interpretation of classic film noir, using many of the same highly stylized cinematic devices, such as the interplay between light and shadow, off-kilter framing and quirky camera angles. This retro-futuristic shoot was a blend of the team's efforts to create a unique interpretation of a well-trodden trend. The Perspex jewellery keeps the image modern-looking.

SHAPE UP

Rather than drawing or painting geometric shapes on the model, you can cut them out of card or stiff foam and fix them to the model's face using embellishment techniques that we will explore further in the next chapter. Play with different thicknesses of card, and consider emphasizing the outline edges. Go back to school and invest in a basic geometry kit with a ruler, compass and protractor so you can draw perfect shapes before cutting out with sharp scissors or a scalpel.

Again, this look owes much to Cubism, and the importance of art history and its influence on makeup cannot be understated. Check out my first book, Art & Makeup, for further artistic inspiration!

SHARP OBJECTS

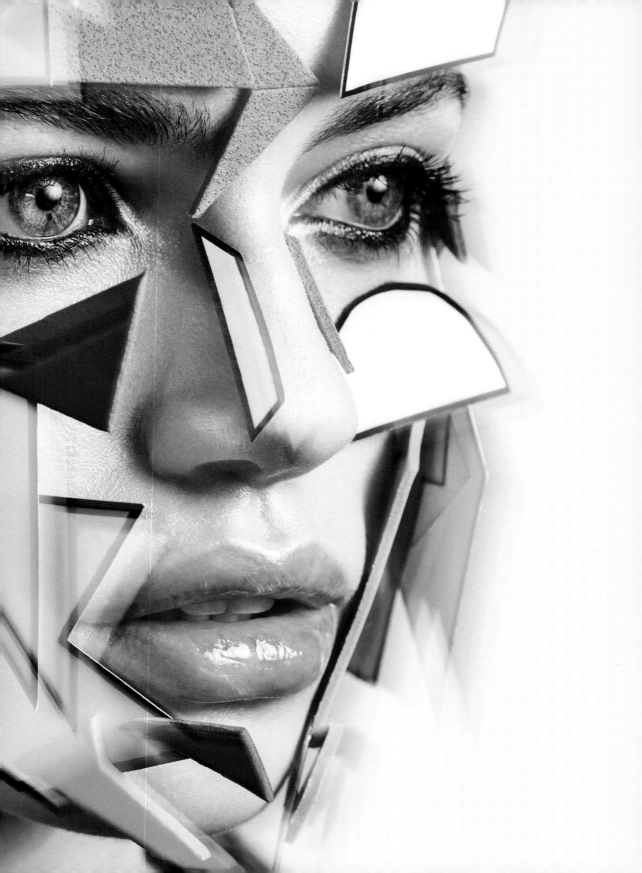

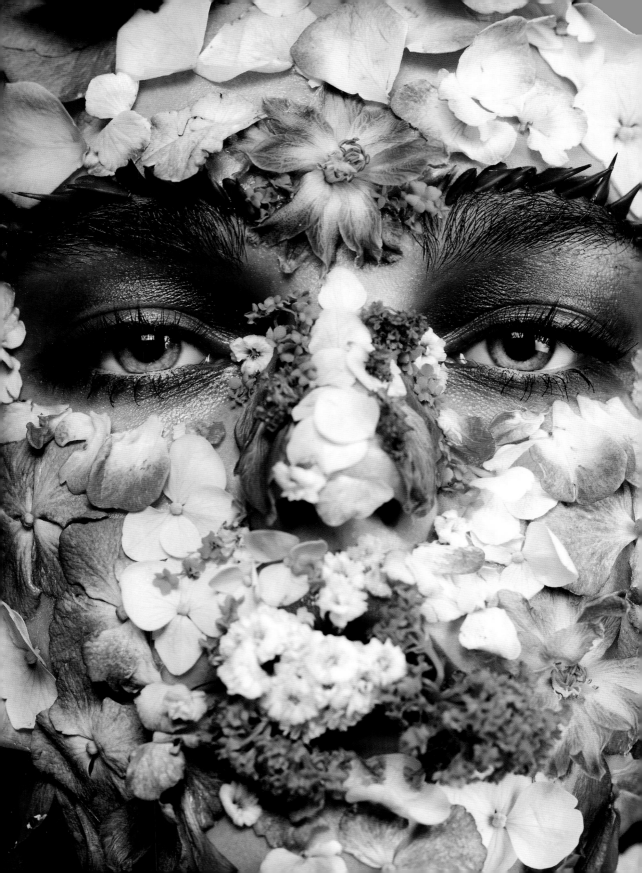

EMBELLISH

The cherry on the cosmetics cake, embellishments are a powerful tool for creating three-dimensional looks with a wow factor. There are (almost) no limits to the kind of accessories you can layer over traditional makeup, and here you will see how to use a variety of materials to help design an elaborate yet balanced look.

In the same way that you would use pale, reflective tones to highlight the skin, and darker, more light-absorbing shades to contour, it is essential to think about the type of material you want to use and how it can be utilized to create similar effects. Study the shape, colour and reflective properties of the material, or materials, and consider how they can be used to offset each other.

When working with embellishments it's best to have a plan – random placement can work, but you're more likely to achieve a strong result if you take time to design the look on a face chart first. When you have a clear picture of what you are trying to achieve, you can be creative in the moment and adapt the design if necessary. The most important rule is to consider placement when designing a look, as embellishments can sometimes overpower the face and look unbalanced. The idea is to enhance, not diminish, the beauty of the face.

KEY KIT

- EYELASH GLUE
- TWEEZERS
- SCISSORS
- WATER SPRAY
- SPIRIT GUM ADHESIVE

IN BLOOM

Flowers are a perennial favourite for beauty shoots, whether fresh, dried or fake, especially in spring and summer editorials. They can be used to create theatrical characters, such as fairies in Shakespeare's *A Midsummer Night's Dream*. On the catwalk they can be used to mirror a floral print or textile design. In an editorial beauty feature they might be used as a hero image to illustrate an article on using natural ingredients.

I began by fixing oversized blooms into the hair, with individual petals broken off to fit more neatly on to the planes of the face. I used the very smallest to fit into the contours of the eye socket and around the nose and mouth. Thorns were used for the eyebrows, adding a contrasting texture. Colour was graduated from the most intense purples on the outer edges of the face to more delicate pinks and white near the nose area.

FRESH FLOWERS

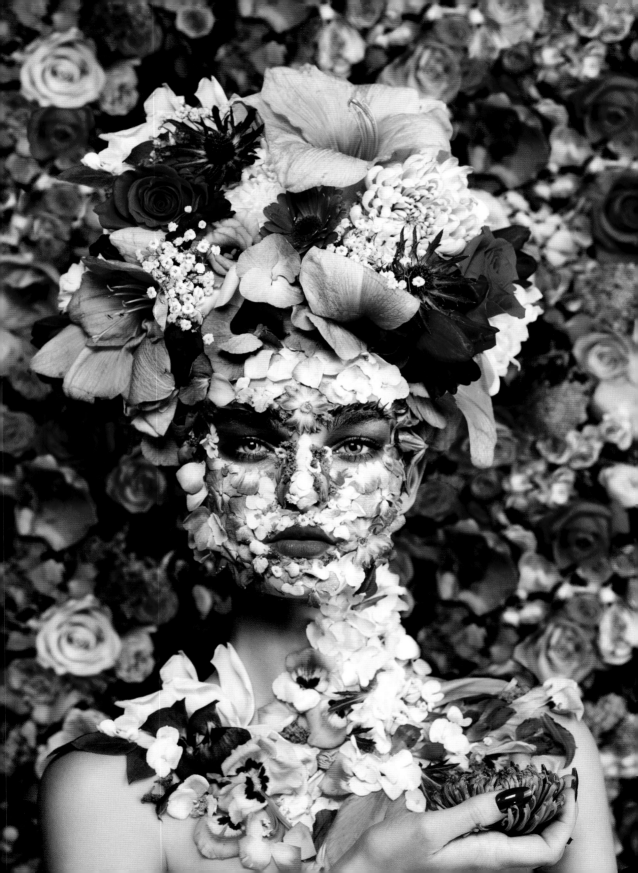

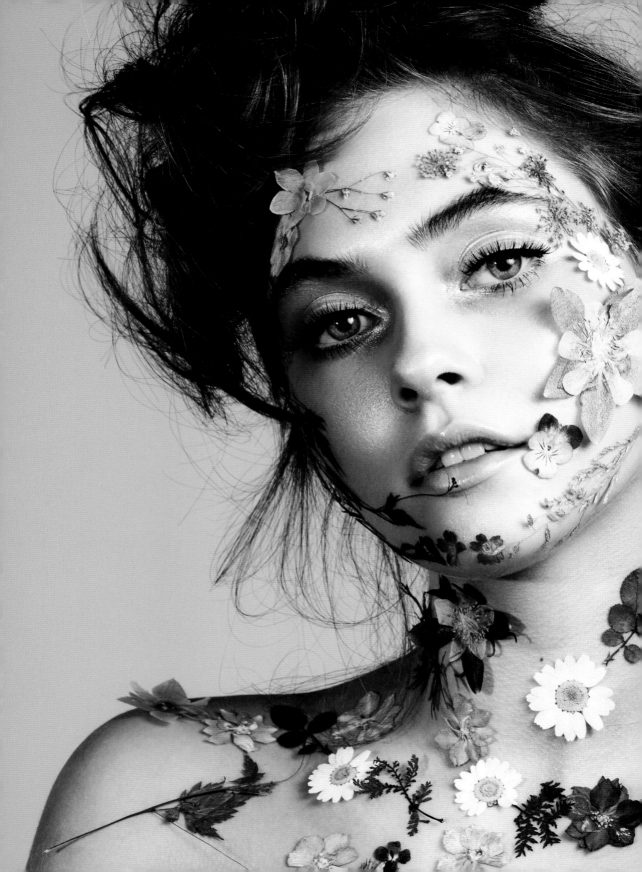

PRESSED WILDFLOWERS

To create this delicate look, I focused on the artful placement of dried flowers to complement the fresh, dewy skin and pretty pastel makeup. Dried flowers are pressed flat and become rigid so are more versatile and easier to use, and while they must still be treated with care, they are much easier to reposition.

BEADS & SEQUINS

As any artist will tell you, small, distinct dots of colour can be used to great effect when placed in patterns to form an image. In art this is called pointillism, and in makeup a similar effect can be created with repetitive placement of beads, pearls, sequins or their oversized cousin – the chic-sounding paillette. Beads can easily be sourced online or from craft stores, and there's a bewildering choice available.

Oversized glitter particles have the same effect as small sequins and lie flush against the skin when pressed on to a Vaseline base. You can build the density of the shiny grains in layers, or sprinkle over for lighter coverage.

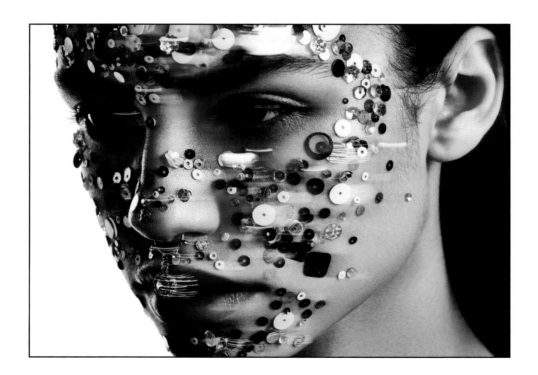

STEAMPUNK

Chunky beads and paillettes add texture. Here, metallic tones give the model a robotic or Steampunk look, as if a tray of tiny cogs and wheels had been scattered over the face.

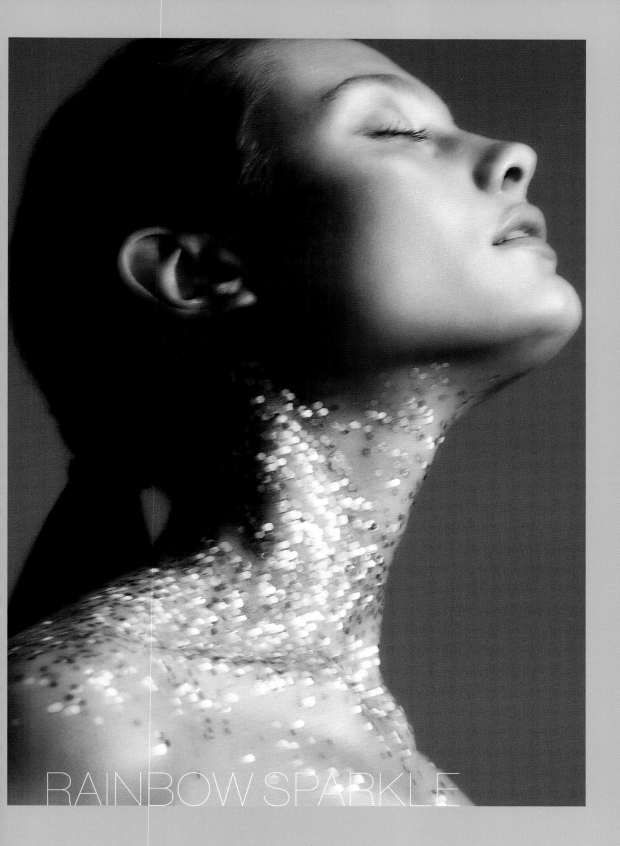

RAINBOW SPARKLE

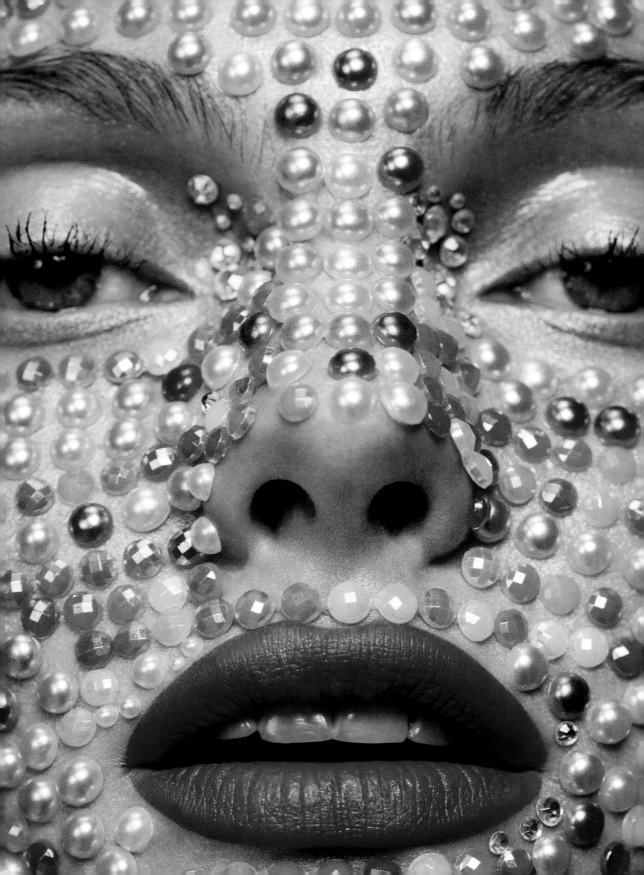

PEARLESCENT

Nature's beads – pearls – can be used for a variety of photoshoot concepts. Tiny variations in surface texture are magnified through the photographer's lens. Here, beads have been fixed with skin-friendly glue and follow the contours of the features. Using a mixture of flat-back crystals for highlights and contouring, the look is balanced with a rich red lip and glossy eye.

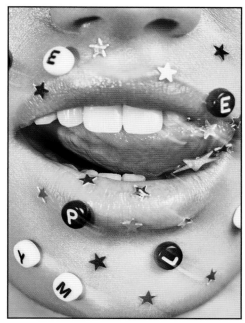

ALPHABETTI CONFETTI

A few carefully placed beads, allowing plenty of skin to shine through, can have as powerful an effect as a fully covered face. Mix them up and experiment with different shapes, colours and finishes.

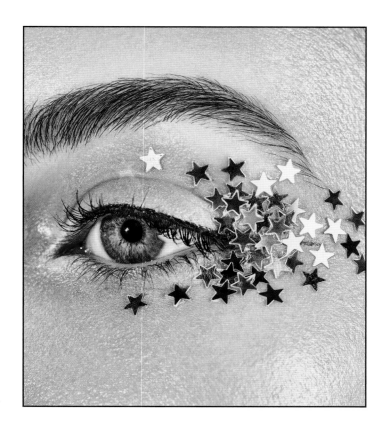

STARRY EYED

Sequins come in many shapes and sizes, from discs to stars, hexagons to leaves, and snowflakes to squares. Gold and silver in particular can add a festive or disco theme to a look.

ANYTHING GOES!

Let your imagination run wild – if you can stick it safely with eyelash glue, spirit gum or non-irritating double-sided tape, then anything goes! There are two ways to go about designing an embellished look: think about the mood or narrative of the editorial shoot or runway collection and source embellishments to match, or be inspired by the material itself and create a look around it.

BEETLE & STUDS

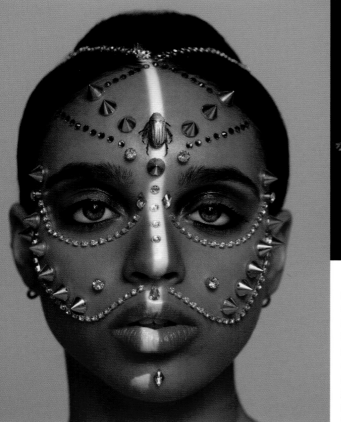

I used a beetle here to give a naturalistic, raw feel. The scarab beetle also has spiritual connotations, and the placement was intended to draw attention to the fabled 'third eye'. Gold studs placed symmetrically across the face frame the beetle. The shard of light added by the photographer intersects the face, acting as a spotlight and leaving the rest of the features in shadow.

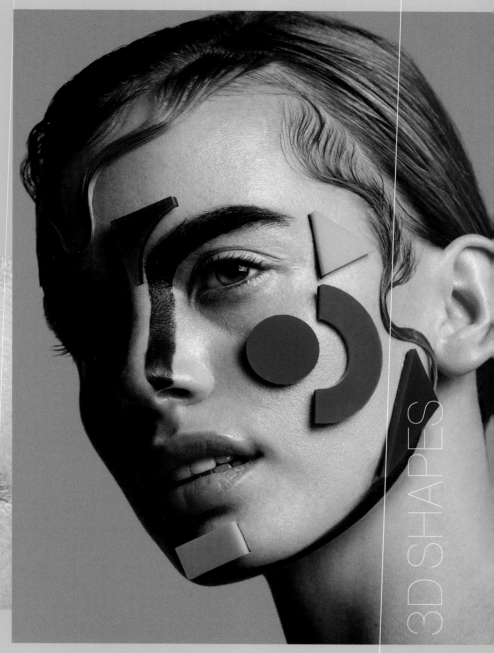

3D SHAPES

POM POMS

Pom poms and bobbles are always a fun way to add colour and a soft, woolly texture. Here, I made the skin flat and white to allow the viewer to focus on the cheerful little balls of fluff.

Felt is a flexible and easy-to-cut material for making embellishment details. Mixing together other techniques from this book, such as fluid painted lines, geometric shapes and the use of bold colour, will ensure you are never short of ideas when it comes to creating a look.

CUT & PASTE

Over the last decade, elaborate and easy-to-apply face sticker designs have become readily available. They have the advantage of being quick to apply if you're backstage at a catwalk show, and can be layered creatively or used to contrast with other textures. You can make your own: any flat, cut-out shape can be affixed using eyelash glue if it's light, or spirit gum if it's heavier.

My obsession with fabulous lips continues here! I mirrored the metallic red, pre-cut lip stickers with a glossy red lip, with the edges kept super-defined as if they were also a sticker. The model is lit with a hard, directional lamp on the left side of her face, which makes the sticker lips appear almost black when in shadow.

STARS & DOTS

Go big ... or go small! Oversized stars give a glam-rock effect, especially when paired with voluminous hair. Tiny dots appear like a constellation of stars, and add a theatrical effect to the makeup look.

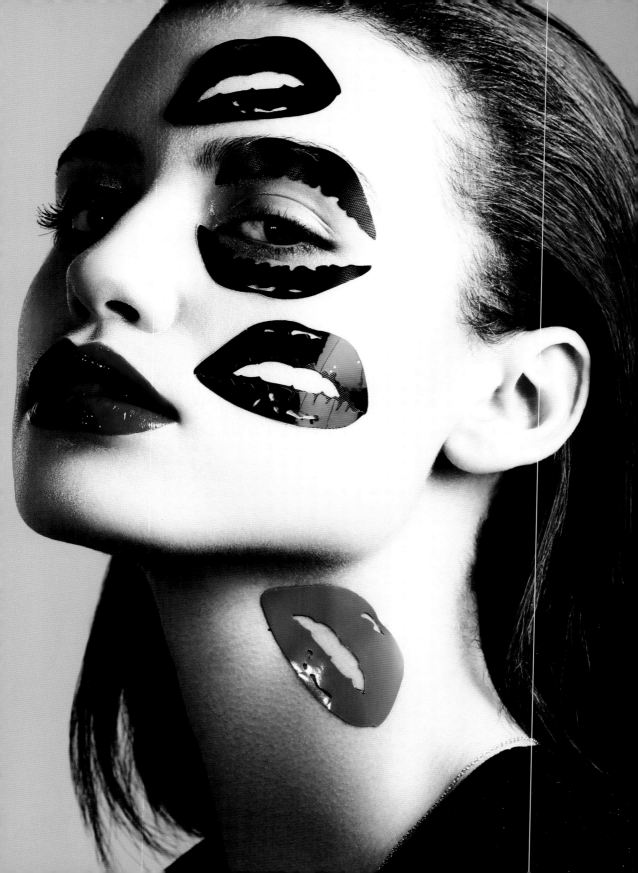

DAZZLE WITH CRYSTALS

Crystals – in this context I include those made of glass, plastic and, if you're really lucky, natural crystals such as gemstones – all have the effect of adding a luxurious sparkle to your look. Tiny facets in the surface of the translucent crystals will reflect and refract light for a luminous effect. It is no wonder this kind of look is often saved for couture runway shows.

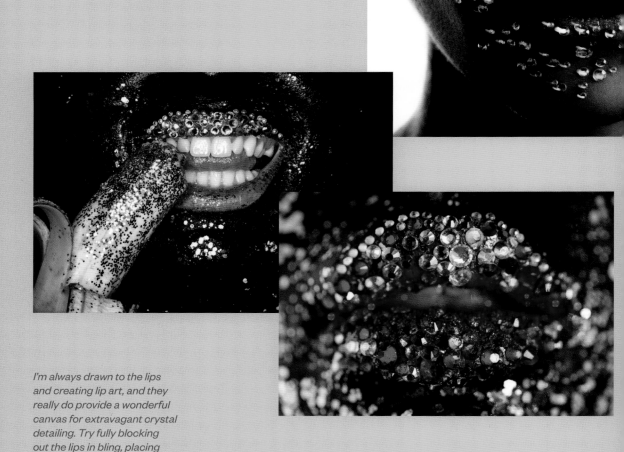

I'm always drawn to the lips and creating lip art, and they really do provide a wonderful canvas for extravagant crystal detailing. Try fully blocking out the lips in bling, placing crystals around the mouth to create a tattoo effect, or use a few stones in a pale colour to emphasize areas of highlight.

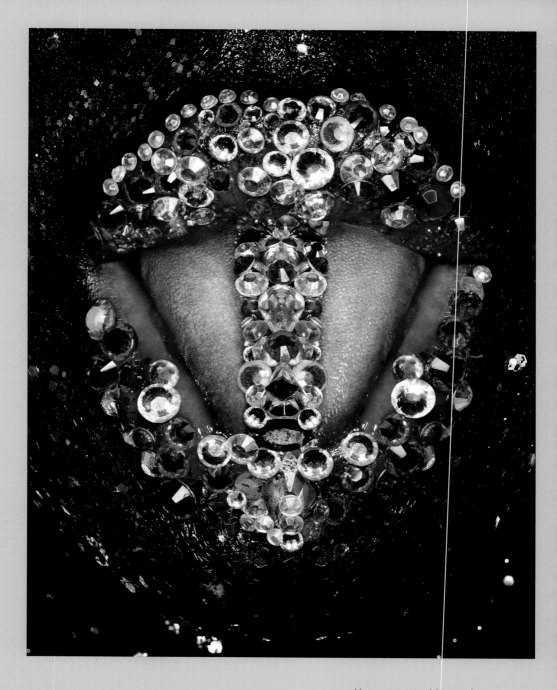

You can even add crystals sparingly to the tongue for an extreme look – here they will stick naturally with saliva. It seems obvious, but make sure the model doesn't swallow them! Use tweezers for precision and only stick to the visible end of the tongue.

BEJEWELLED LIPS

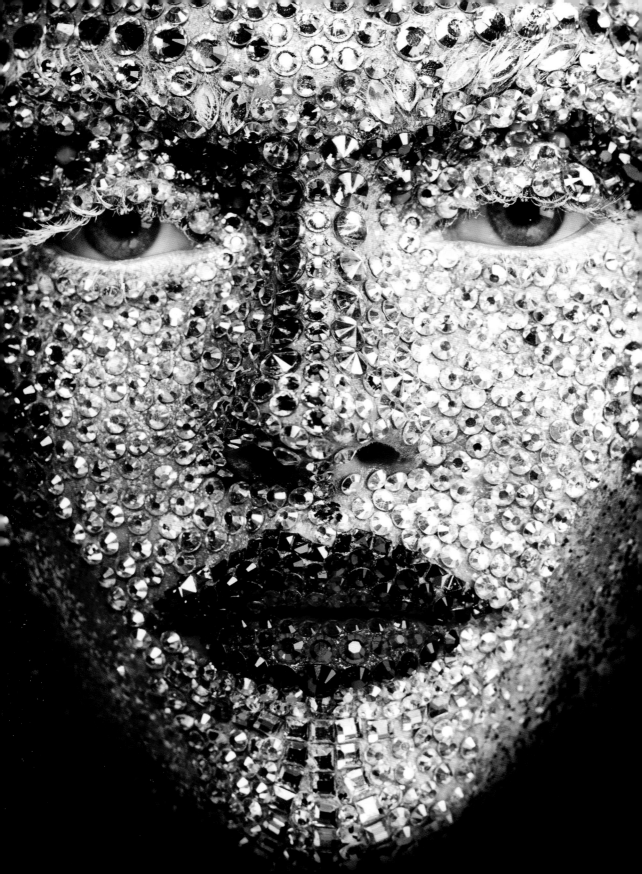

CRYSTALLINE
CONTOURS

This full-face crystal and glitter combination was incredibly time-consuming, taking six hours to complete. The layers were built first with makeup, mapping out the areas of contour and highlight. Crystals were sorted according to size, shape and colour, and assigned to these different 'panels' of the face. When the whole face is to be covered, mapping out and preparation are key for pulling off a successful, balanced look.

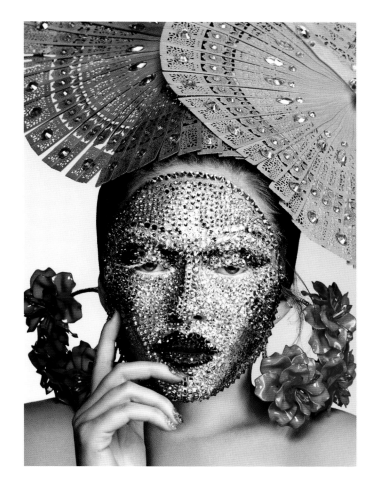

PICTURE CREDITS

Face charts by Dena Cooper www.denacooper.com
Front cover Photographer John Oakley; Model Gina Harrison
Back cover (top middle) Photographer Tim Bret-Day; Hair Joseph Koniak; Stylist Rebekah Roy; Model Daria Stadler @ Profile: (top right) Photographer Jonny Storey; Hair Antoinette Aderotoye; Model Kihoko @ Body London: (bottom left and middle) Photographer Simon Songhurst; Hair Luke Pluckrose; Model Elle Trowbridge @ Elite: (bottom right) Photographer Simon Songhurst; Hair Luke Pluckrose; Model Hannah Murrell @ Nevs

6 Photographer John Oakley; Model Gina Harrison **9** Photographer Lan Nguyen-Grealis **12, 19** Photographer John Rawson @ TRP; Hair Luke Pluckrose; Model Elle Dowling @ Models 1; Flowers by Ryan at Love Flowers UK **14** Photographer Camille Sanson; Hair Luke Pluckrose; Model Zoey Kay @ Nevs **16** Photographer Simon Songhurst; Model Stacey Hannant @ Body London **17** Photographer Dami Oyetade; Hair Adam Garland; Model Tiffany Johnson @ PRM Agency **20** Photographer Daniel Nadel; Hair Joseph Koniak; Stylist Rebekah Roy; Model Hannah Murrell @ Nevs wearing dress by Tramp in Disguise **21** Photographer Tim Bret-Day; Hair Joseph Koniak; Stylist Rebekah Roy; Model Ekaterina Stukanova @ Women Management wearing dress by Andrew Majtenyi **22, 23** Photographer Benjamin Madgwick; Model Claudia Etherington @ Models 1 **24, 25** Photographer Mike Blackett; Hair Joseph Koniak; Model Georgie Hobday @ Profile **26** (top) Photographer Daniel Nadel; Hair Joseph Koniak; Model Sylwia Plochocka @ PRM Agency: (bottom) Photographer Tim Bret-Day; Hair Joseph Koniak; Stylist Rebekah Roy; Model Ekaterina Stukanova @ Women Management wearing Big Bang bracelet by Tina Lilienthal and rings by Lucy Ashton **27** Photographer Simon Songhurst; Model Elle Trowbridge @ Elite **28** Photographer Benjamin Madgwick; Model Claudia Etherington @ Models 1
31 Photographer Benjamin Madgwick; Model Claudia Etherington @ Models 1 **32** Photographer Mike Blackett; Hair Joseph Koniak; Model Georgie Hobday @ Profile **33** Photographer Tim Bret-Day; Hair Joseph Koniak; Stylist Rebekah Roy; Model Daria Stadler @ Profile wearing neckpiece by Michelle Lowe-Holder **34, 35** Photographer Dami Oyetade; Hair Adam Garland; Model Tiffany Johnson @ PRM Agency **36, 37** Photographer Daniel Nadel; Hair Joseph Koniak; Model Sylwia Plochocka @ PRM Agency **38** Photographer Simon Songhurst; Hair Luke Pluckrose; Model Hannah Murrell @ Nevs **39** (left) Photographer Mike Blackett; Hair Joseph Koniak; Model Georgie Hobday @ Profile: (right) Photographer Simon Songhurst; Model Elle Trowbridge @ Elite **40** Photographer John Rawson @ TRP; Hair Luke Pluckrose; Model Anna Tatton @ Nevs
42 Photographer Benjamin Madgwick; Model Claudia Etherington @ Models 1 **44** (left) Photographer Jonny Storey; Hair Antoinette Aderotoye; Model Stacey Hannant @ Body London: (right) Photographer Dami Oyetade; Hair Adam Garland; Model Tiffany Johnson @ PRM Agency **45** Photographer Jonny Storey; Model Ines Williams @ PRM Agency **46** Photographer John Oakley; Model Gina Harrison **48** Photographer Daniel Nadel; Hair Joseph Koniak; Stylist Rebekah Roy; Model Sylwia Plochocka @ PRM Agency **50, 51** Photographer John Rawson @ TRP; Hair Luke Pluckrose; Model Hannah Murrell @ Nevs wearing headpiece by Ashley Isham and outfit made of hair by Luke Pluckrose **52** (left) Photographer Tim Bret-Day; Hair Joseph Koniak; Model Ekaterina Stukanova @ Women Management: (right) Photographer Dami Oyetade; Hair Adam Garland; Model Tiffany Johnson @ PRM Agency **53** Photographer John Rawson @ TRP; Hair Luke Pluckrose; Model Anna Tatton @ Nevs **54** Photographer Daniel Nadel; Hair Joseph Koniak; Stylist Rebekah Roy; Model Hannah Murrell @ Nevs wearing dress by Zeynep Kartal **55** (top) Photographer Simon Songhurst; Hair Luke Pluckrose Model Hannah Murrell @ Nevs: (middle) Photographer Jonny Storey; Hair Antoinette Aderotoye; Model Kihoko @ Body London: (bottom) Photographer Simon Songhurst; Hair Luke Pluckrose; Model Hannah Murrell @ Nevs **56** Photographer Daniel Nadel; Hair Joseph Koniak; Stylist Rebekah Roy; Model Hannah Murrell @ Nevs wearing dress by Nicola Brindle **57** Photographer Tim Bret-Day; Hair Joseph Koniak;

Stylist Rebekah Roy; Model Ekaterina Stukanova @ Women Management wearing hat by Emma Brewin **58, 59** Photographer Daniel Nadel; Hair Joseph Koniak; Stylist Rebekah Roy; Model Hannah Murrell @ Nevs wearing dress by Point Blank **60, 61** Photographer John Rawson @ TRP; Hair Luke Pluckrose; Model Gina Harrison **62, 63** Photographer Camille Sanson; Hair Luke Pluckrose; Model Zoey Kay @ Nevs **64, 67** Photographer Jonny Storey; Hair Antoinette Aderotoye; Model Ines Williams @ PRM Agency **68** Photographer Jonny Storey; Model Stacey Hannant @ Body London **70** (top) Photographer Jonny Storey; Model Stacey Hannant @ Body London: (middle) Photographer John Oakley; Model Gina Harrison: (bottom) Photographer John Oakley; Model Wilma Stigson @ Flawless Model Agency **71** (top and middle) Photographer John Oakley; Model Wilma Stigson @ Flawless Model Agency: (bottom) Photographer John Oakley; Model Gina Harrison **72** Photographer Daniel Nadel; Hair Joseph Koniak; Stylist Rebekah Roy; Model Sylwia Plochocka @ PRM Agency wearing dress by Andrew Majtenyi with added lace and tulle **73** Photographer Jonny Storey; Hair Antoinette Aderotoye; Model Kihoko @ Body London **74, 75** Photographer Simon Songhurst; Hair Luke Pluckrose; Model Hannah Murrell @ Nevs **76, 77** Photographer Simon Songhurst; Hair Luke Pluckrose; Model Hannah Murrell @ Nevs **78, 80** Photographer Jonny Storey; Hair Antoinette Aderotoye; Model Kihoko @ Body London **81** Photographer John Rawson @ TRP; Hair Luke Pluckrose; Model Ellen Burton @ Profile **82** Photographer Tim Bret-Day; Hair Joseph Koniak; Stylist Rebekah Roy; Model Ekaterina Stukanova @ Women Management wearing jacket by RUN **84, 85** Photographer Camille Sanson; Hair Luke Pluckrose; Model Zoey Kay @ Nevs **86, 87** Photographer Tim Bret-Day; Hair Joseph Koniak; Stylist Rebekah Roy; Model Ekaterina Stukanova @ Women Management wearing (left) coat by Jayne Pierson with earrings by Dyelog PR and (right) dress by Sabrina **88** Photographer Daniel Nadel; Hair Joseph Koniak; Stylist Rebekah Roy; Model Hannah Murrell @ Nevs **90** Photographer Tim Bret-Day; Hair Joseph Koniak; Stylist Rebekah Roy; Model Daria Stadler @ Profile wearing necklaces by Sarah Angold and swimsuit by Emma Pake **92, 93** Photographer Simon Songhurst; Hair Luke Pluckrose; Model Elle Trowbridge @ Elite **94, 97** Photographer John Rawson @ TRP; Hair Luke Pluckrose; Model Ellen Burton @ Profile; Flowers by Ryan at Love Flowers UK **98, 99** Photographer Simon Songhurst; Hair Luke Pluckrose; Model Hannah Murrell @ Nevs **100** Photographer Simon Songhurst Hair Luke Pluckrose Model Hannah Murrell @ Nevs **101** Photographer Mike Blackett; Hair Joseph Koniak; Model Georgie Hobday @ Profile
102 Photographer Mike Blackett; Hair Joseph Koniak; Model Georgie Hobday @ Profile **103** Photographer Simon Songhurst; Model Elle Trowbridge @ Elite **104** (left) Photographer Jonny Storey; Hair Antoinette Aderotoye; Model Ines Williams @ PRM Agency: (middle) Photographer John Oakley; Model Gina Harrison: (right) Photographer Jonny Storey; Hair Antoinette Aderotoye; Model Stacey Hannant @ Body London **105** Photographer Jonny Storey; Hair Antoinette Aderotoye; Model Stacey Hannant @ Body London **106** (left) Photographer Simon Songhurst; Hair Luke Pluckrose; Model Elle Trowbridge @ Elite: (right) Photographer Daniel Nadel; Hair Joseph Koniak; Stylist Rebekah Roy; Model Hannah Murrell @ Nevs **107** Photographer Simon Songhurst; Hair Luke Pluckrose; Model Elle Trowbridge @ Elite **108** (top) Photographer Simon Songhurst; Model Elle Trowbridge @ Elite: (left and bottom) and **109** Photographer John Oakley; Model Gina Harrison **110, 111** Photographer John Rawson @ TRP; Hair Luke Pluckrose; Model Hannah Murrell @ Nevs wearing Ashley Isham hat and earrings **114** Photographer Lan Nguyen-Grealis

Special thanks to the following makeup assistants for their help throughout this book: Kelly Mendiola, Yelena Konnova, Jenny Morrell, Eoin Whelan, Hannah Davies, Wilma Stigson and Grace Hayward.

FACE CHARTS

MAKEUP

LOOK/OCCASION

SKIN
Primer
Foundation
Concealer
Powder
Highlighter
Contour
Blush

EYES
Brow bone
Lid
Crease
Under eye
Eyeliner
Mascara
Brow

LIPS
Lip liner
Lipstick
Gloss

KEY PRODUCTS AND TOOLS

INSPIRATION

NOTES

MAKEUP

LOOK/OCCASION ...

SKIN

Primer ...

Foundation ...

Concealer ...

Powder ...

Highlighter ...

Contour ...

Blush ...

EYES

Brow bone ...

Lid ...

Crease ...

Under eye ...

Eyeliner ...

Mascara ...

Brow ...

LIPS

Lip liner ...

Lipstick ...

Gloss ...

KEY PRODUCTS AND TOOLS ...

...

...

INSPIRATION ...

...

...

NOTES ...

...

...

...

...

MAKEUP

LOOK/OCCASION

SKIN

Primer

Foundation

Concealer

Powder

Highlighter

Contour

Blush

EYES

Brow bone

Lid

Crease

Under eye

Eyeliner

Mascara

Brow

LIPS

Lip liner

Lipstick

Gloss

KEY PRODUCTS AND TOOLS

INSPIRATION

NOTES

MAKEUP

SKIN
Primer
Foundation
Concealer
Powder
Highlighter
Contour
Blush

EYES
Brow bone
Lid
Crease
Under eye
Eyeliner
Mascara
Brow

LIPS
Lip liner
Lipstick
Gloss

KEY PRODUCTS AND TOOLS

INSPIRATION

NOTES

MAKEUP

LOOK/OCCASION ...

SKIN

Primer

Foundation ...

Concealer ...

Powder ...

Highlighter ...

Contour ...

Blush ...

EYES

Brow bone ...

Lid ...

Crease ...

Under eye ...

Eyeliner ...

Mascara ...

Brow ...

LIPS

Lip liner ...

Lipstick ...

Gloss ...

KEY PRODUCTS AND TOOLS ...

...

...

INSPIRATION ...

...

NOTES ...

...

...

...

MAKEUP

LOOK/OCCASION ...

SKIN
Primer ...
Foundation ...
Concealer ...
Powder ...
Highlighter ...
Contour ...
Blush ...

EYES
Brow bone ..
Lid ...
Crease ...
Under eye ...
Eyeliner ..
Mascara ..
Brow ...

LIPS
Lip liner ..
Lipstick ...
Gloss ...

KEY PRODUCTS AND TOOLS ...
...
...

INSPIRATION ..
...
...

NOTES ...
...
...
...
...

MAKEUP

LOOK/OCCASION ...

SKIN

Primer ..

Foundation ..

Concealer ...

Powder ..

Highlighter ..

Contour ...

Blush ...

EYES

Brow bone ...

Lid ...

Crease ..

Under eye ..

Eyeliner ...

Mascara ..

Brow ..

LIPS

Lip liner ...

Lipstick ..

Gloss ...

KEY PRODUCTS AND TOOLS ..

...

...

INSPIRATION ...

...

...

NOTES ...

...

...

...

...

MAKEUP

LOOK/OCCASION ..

SKIN

Primer ..

Foundation ..

Concealer ..

Powder ..

Highlighter ..

Contour ..

Blush ..

EYES

Brow bone ..

Lid ..

Crease ..

Under eye ..

Eyeliner ..

Mascara ..

Brow ..

LIPS

Lip liner ..

Lipstick ..

Gloss ..

KEY PRODUCTS AND TOOLS ..

..

..

INSPIRATION ..

..

..

NOTES ..

..

..

..

..

MAKEUP

LOOK/OCCASION ..

SKIN

Primer ..

Foundation ..

Concealer ..

Powder ..

Highlighter ..

Contour ..

Blush ..

EYES

Brow bone ..

Lid ..

Crease ..

Under eye ..

Eyeliner ..

Mascara ..

Brow ..

LIPS

Lip liner ..

Lipstick ..

Gloss ..

KEY PRODUCTS AND TOOLS ..

..

..

INSPIRATION ..

..

..

NOTES ..

..

..

..

..

MAKEUP

LOOK/OCCASION ..

SKIN

Primer ..

Foundation ..

Concealer ..

Powder ..

Highlighter ..

Contour ..

Blush ..

EYES

Brow bone ..

Lid ..

Crease ..

Under eye ..

Eyeliner ..

Mascara ..

Brow ..

LIPS

Lip liner ..

Lipstick ..

Gloss ..

KEY PRODUCTS AND TOOLS ..

..

..

INSPIRATION ..

..

..

NOTES ..

..

..

..

..

MAKEUP

LOOK/OCCASION ...

SKIN
Primer ...
Foundation ...
Concealer ...
Powder ..
Highlighter ...
Contour ...
Blush ..

EYES
Brow bone ..
Lid ...
Crease ..
Under eye ...
Eyeliner ..
Mascara ...
Brow ..

LIPS
Lip liner ...
Lipstick ..
Gloss ...

KEY PRODUCTS AND TOOLS ...
...
...

INSPIRATION ...
...
...

NOTES ...
...
...
...
...

MAKEUP

LOOK/OCCASION ..

SKIN

Primer ..

Foundation ..

Concealer ..

Powder ..

Highlighter ..

Contour ..

Blush ..

EYES

Brow bone ..

Lid ..

Crease ..

Under eye ..

Eyeliner ..

Mascara ..

Brow ..

LIPS

Lip liner ..

Lipstick ..

Gloss ..

KEY PRODUCTS AND TOOLS

..

..

INSPIRATION

..

..

NOTES

..

..

..

..

MAKEUP

LOOK/OCCASION ...

SKIN

Primer ...

Foundation ...

Concealer ..

Powder ..

Highlighter ...

Contour ...

Blush ..

EYES

Brow bone ..

Lid ...

Crease ..

Under eye ..

Eyeliner ...

Mascara ..

Brow ...

LIPS

Lip liner ...

Lipstick ..

Gloss ..

KEY PRODUCTS AND TOOLS ..

...

...

INSPIRATION ..

...

...

NOTES ...

...

...

...

...

MAKEUP

LOOK/OCCASION ..

SKIN

Primer ..

Foundation ..

Concealer ..

Powder ..

Highlighter ..

Contour ..

Blush ..

EYES

Brow bone ..

Lid ..

Crease ..

Under eye ..

Eyeliner ..

Mascara ..

Brow ..

LIPS

Lip liner ..

Lipstick ..

Gloss ..

KEY PRODUCTS AND TOOLS ..

..

INSPIRATION ..

..

NOTES ..

..

..

..

MAKEUP

LOOK/OCCASION ..

SKIN

Primer ..

Foundation ..

Concealer ..

Powder ..

Highlighter ..

Contour ..

Blush ..

EYES

Brow bone ..

Lid ..

Crease ..

Under eye ..

Eyeliner ..

Mascara ..

Brow ..

LIPS

Lip liner ..

Lipstick ..

Gloss ..

KEY PRODUCTS AND TOOLS

..

..

INSPIRATION

..

..

NOTES

..

..

..

..

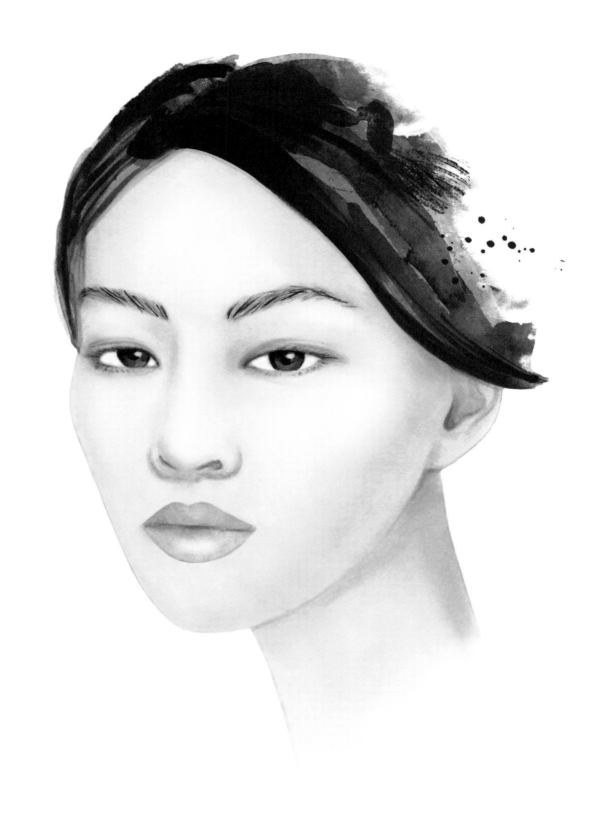

MAKEUP

LOOK/OCCASION ...

SKIN

Primer ...

Foundation ...

Concealer ...

Powder ...

Highlighter ...

Contour ...

Blush ...

EYES

Brow bone ...

Lid ...

Crease ...

Under eye ...

Eyeliner ...

Mascara ...

Brow ...

LIPS

Lip liner ...

Lipstick ...

Gloss ...

KEY PRODUCTS AND TOOLS ...

...

...

INSPIRATION ...

...

...

NOTES ...

...

...

...

...

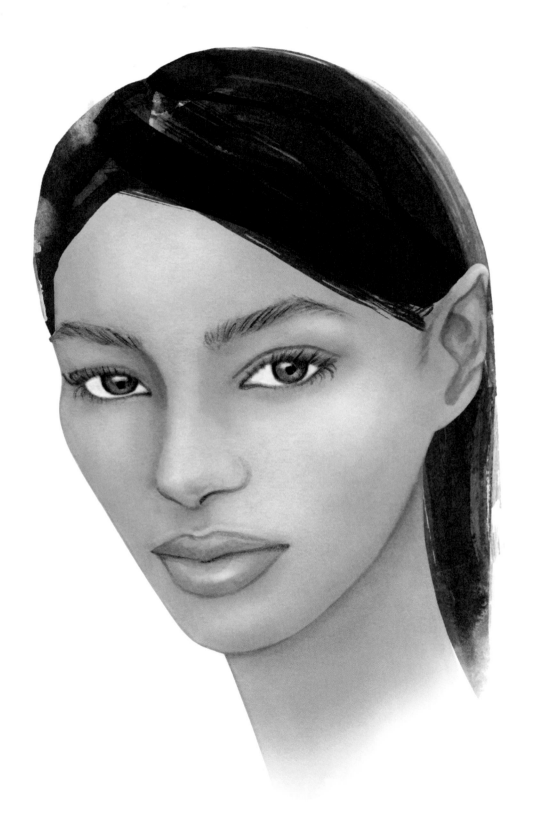

MAKEUP

LOOK/OCCASION ...

SKIN

Primer ..

Foundation ..

Concealer ...

Powder ...

Highlighter ..

Contour ..

Blush ...

EYES

Brow bone ...

Lid ..

Crease ...

Under eye ...

Eyeliner ..

Mascara ...

Brow ...

LIPS

Lip liner ..

Lipstick ..

Gloss ...

KEY PRODUCTS AND TOOLS ...

...

...

INSPIRATION ..

...

...

NOTES ...

...

...

...

...

MAKEUP

LOOK/OCCASION ...

SKIN

Primer ...

Foundation ...

Concealer ...

Powder ...

Highlighter ...

Contour ...

Blush ...

EYES

Brow bone ...

Lid ...

Crease ...

Under eye ...

Eyeliner ...

Mascara ...

Brow ...

LIPS

Lip liner ...

Lipstick ...

Gloss ...

KEY PRODUCTS AND TOOLS ...

...

...

INSPIRATION ...

...

...

NOTES ...

...

...

...

...

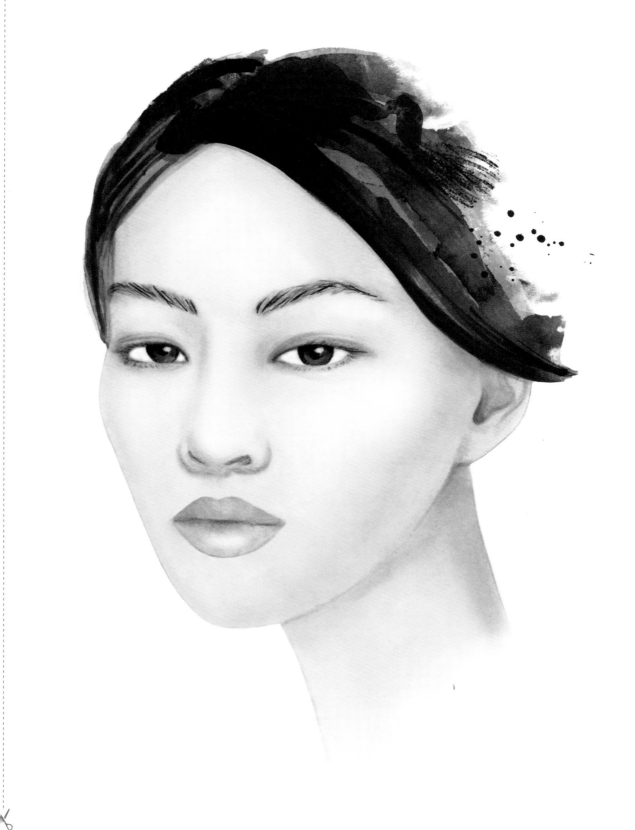

MAKEUP

LOOK/OCCASION

SKIN
Primer
Foundation
Concealer
Powder
Highlighter
Contour
Blush

EYES
Brow bone
Lid
Crease
Under eye
Eyeliner
Mascara
Brow

LIPS
Lip liner
Lipstick
Gloss

KEY PRODUCTS AND TOOLS

INSPIRATION

NOTES

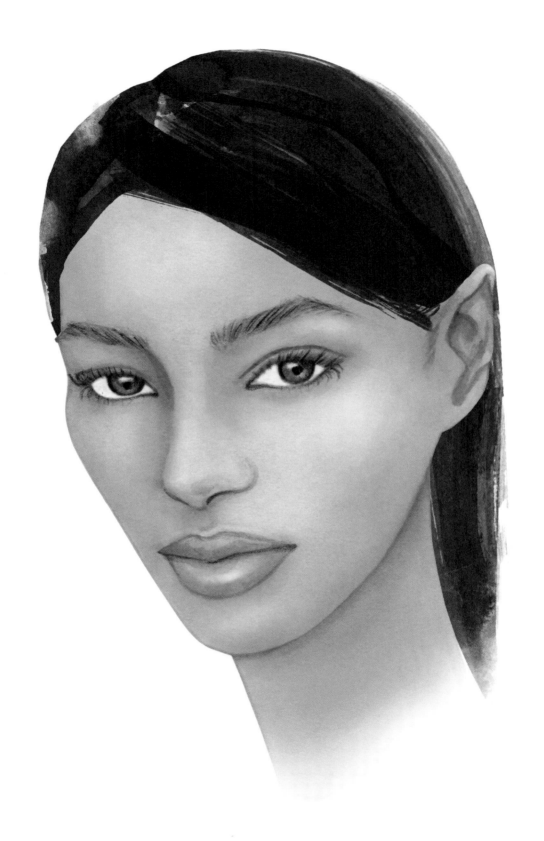

MAKEUP

LOOK/OCCASION ..

SKIN

Primer ..

Foundation ..

Concealer ..

Powder ..

Highlighter ..

Contour ..

Blush ..

EYES

Brow bone ..

Lid ..

Crease ..

Under eye ..

Eyeliner ..

Mascara ..

Brow ..

LIPS

Lip liner ..

Lipstick ..

Gloss ..

KEY PRODUCTS AND TOOLS ..

..

..

INSPIRATION ..

..

..

NOTES ..

..

..

..

..

MAKEUP

LOOK/OCCASION ..

SKIN
Primer ..
Foundation ..
Concealer ..
Powder ..
Highlighter ..
Contour ..
Blush ..

EYES
Brow bone ..
Lid ..
Crease ..
Under eye ..
Eyeliner ..
Mascara ..
Brow ..

LIPS
Lip liner ..
Lipstick ..
Gloss ..

KEY PRODUCTS AND TOOLS ..
..
..

INSPIRATION ..
..
..

NOTES ..
..
..
..

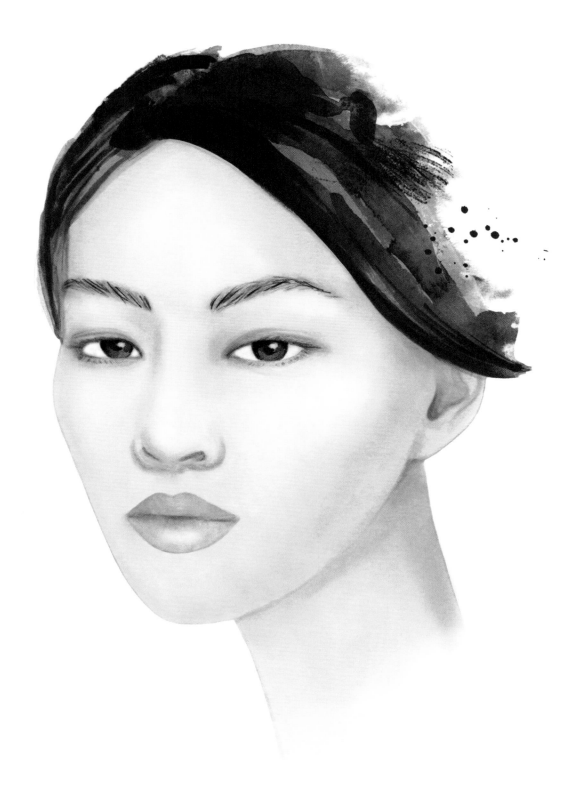

MAKEUP

LOOK/OCCASION

SKIN

Primer

Foundation

Concealer

Powder

Highlighter

Contour

Blush

EYES

Brow bone

Lid

Crease

Under eye

Eyeliner

Mascara

Brow

LIPS

Lip liner

Lipstick

Gloss

KEY PRODUCTS AND TOOLS

INSPIRATION

NOTES

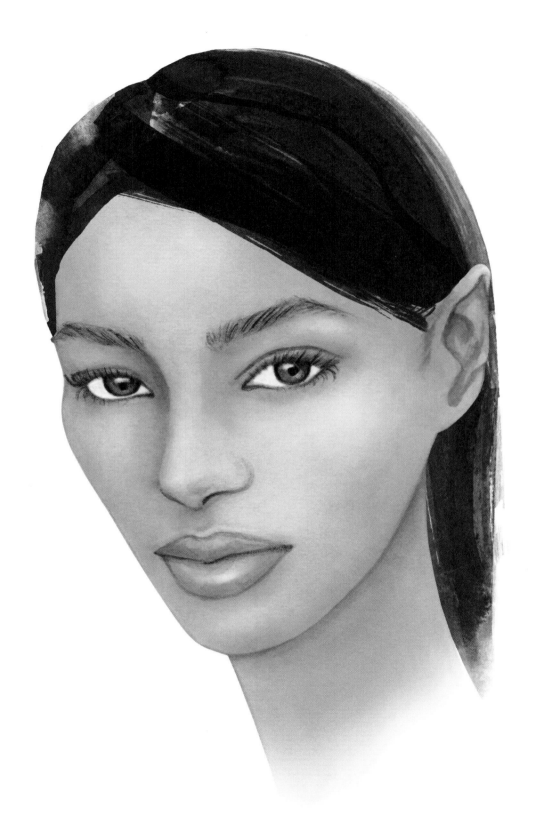

MAKEUP

LOOK/OCCASION ..

SKIN

Primer ..

Foundation ..

Concealer ..

Powder ..

Highlighter ..

Contour ..

Blush ..

EYES

Brow bone ..

Lid ..

Crease ..

Under eye ..

Eyeliner ..

Mascara ..

Brow ..

LIPS

Lip liner ..

Lipstick ..

Gloss ..

KEY PRODUCTS AND TOOLS ..

..

..

INSPIRATION ..

..

..

NOTES ..

..

..

..

MAKEUP

LOOK/OCCASION ...

SKIN

Primer ...

Foundation ...

Concealer ...

Powder ...

Highlighter ...

Contour ...

Blush ...

EYES

Brow bone ...

Lid ...

Crease ...

Under eye ...

Eyeliner ...

Mascara ...

Brow ...

LIPS

Lip liner ...

Lipstick ...

Gloss ...

KEY PRODUCTS AND TOOLS ...

...

...

INSPIRATION ...

...

...

NOTES ...

...

...

...

...

MAKEUP

LOOK/OCCASION

SKIN
Primer
Foundation
Concealer
Powder
Highlighter
Contour
Blush

EYES
Brow bone
Lid
Crease
Under eye
Eyeliner
Mascara
Brow

LIPS
Lip liner
Lipstick
Gloss

KEY PRODUCTS AND TOOLS

INSPIRATION

NOTES

MAKEUP

LOOK/OCCASION

SKIN

Primer

Foundation

Concealer

Powder

Highlighter

Contour

Blush

EYES

Brow bone

Lid

Crease

Under eye

Eyeliner

Mascara

Brow

LIPS

Lip liner

Lipstick

Gloss

KEY PRODUCTS AND TOOLS

INSPIRATION

NOTES

MAKEUP

LOOK/OCCASION ..

SKIN

Primer ..

Foundation ..

Concealer ..

Powder ..

Highlighter ..

Contour ..

Blush ..

EYES

Brow bone ..

Lid ..

Crease ..

Under eye ..

Eyeliner ..

Mascara ..

Brow ..

LIPS

Lip liner ..

Lipstick ..

Gloss ..

KEY PRODUCTS AND TOOLS ..

..

..

INSPIRATION ..

..

..

NOTES ..

..

..

..

..

MAKEUP

LOOK/OCCASION ..

SKIN

Primer ..

Foundation ..

Concealer ..

Powder ..

Highlighter ..

Contour ..

Blush ..

EYES

Brow bone ..

Lid ..

Crease ..

Under eye ..

Eyeliner ..

Mascara ..

Brow ..

LIPS

Lip liner ..

Lipstick ..

Gloss ..

KEY PRODUCTS AND TOOLS ..

..

..

INSPIRATION ..

..

..

NOTES ..

..

..

..

..

MAKEUP

LOOK/OCCASION ...

SKIN

Primer ...

Foundation ...

Concealer ...

Powder ...

Highlighter ...

Contour ...

Blush ...

EYES

Brow bone ...

Lid ...

Crease ...

Under eye ...

Eyeliner ...

Mascara ...

Brow ...

LIPS

Lip liner ...

Lipstick ...

Gloss ...

KEY PRODUCTS AND TOOLS ...
...
...

INSPIRATION ...
...
...

NOTES ...
...
...
...
...

MAKEUP

LOOK/OCCASION

SKIN
Primer
Foundation
Concealer
Powder
Highlighter
Contour
Blush

EYES
Brow bone
Lid
Crease
Under eye
Eyeliner
Mascara
Brow

LIPS
Lip liner
Lipstick
Gloss

KEY PRODUCTS AND TOOLS

INSPIRATION

NOTES

ACKNOWLEDGEMENTS

'May the road rise up to meet you', as my Irish countrymen say. The reality is, the path is never that straightforward! You would think it gets easier as you go along because you have done it before, but creating something that comes from the gut is always a risk, and, as I come to the end of this journey, I'm so happy to be here, finally, writing my thank yous.

From the bottom of my heart I thank everyone for all the hard work involved in creating this book.

Firstly, I'm so grateful to photographers Camille Sanson, Tim Bret-Day, John Rawson, Mike Blackett, John Oakley, Benjamin Madgwick, Simon Songhurst, Daniel Nadel, Jonny Storey and Dami Oyetade, who saw my vision and gave up their time to capture all the images for the book. Without you and your amazing input I wouldn't have been able to achieve this. You are my partners in crime and your visions always add so much more.

Thank you to all the models and agents who helped support the book and make my life a little easier by supplying the beautiful canvases I was able to paint and create with. Especially when we worked long days to get the shots done. I am inspired by you all.

To the wonderful hairstylists Adam Garland, Joesph Koniak, Luke Pluckrose and Antoinette Aderotoye, and stylist Rebekah Roy, who helped to complement the looks and add an extra dimension to my ideas – thanks for standing by me, bringing your creativity to the table, and also for your injection of fun and atmosphere to the shoot days. It means a lot to me.

I would like to especially thank my team of assistants who, over the years, have always been by my side and have been wonderfully patient with helping with research material, shoot days and generally helping to organize where needed. You are truly amazing and are like my extended family, I'm so thankful for your generosity.

Thank you to Roopa Pandit and team for all the help and the use of Smashbox Studios UK to shoot many of the looks. It really was a big help to have our own little space to use when needed.

A huge thank you goes to my talented co-writer Hannah Kane for all her support. She has worked on both of my books and has been instrumental in getting them finished. Hannah, you have been amazingly kind over the years. I'm honoured to have you be part of this project and I'm sure the world will be reading your own book one day!

A special thank you to my publisher Laurence King, and to Jo Lightfoot and Gaynor Sermon for once again trusting in my work and producing this book in record time. Big thanks also go to designer Amira Prescott and illustrator Dena Cooper. I really appreciate all the input of the team, the dedication, suggestions and persistence in wanting to make it the best that it can be.

Finally, endless thanks to all the brands for supporting my work with their amazing products, and to the one-and-only, forever positive and generous 'Mister Makeup' AKA Adam Minto, who I met many moons ago and who has given this project a lifeline. I thank you for your support and opportunities for collaboration. I will always remember your positive words of wisdom and your act of kindness to help my vision.

And, of course, I dedicate this book to my amazingly supportive husband Brendan and daughter Eva Marie, who have both been my everything, constantly uplifting me when times are hard. Your unconditional love inspires me to be the best I can, and I'm grateful that you allow me to be the creative crazy 'me'. To my extended family and friends, too many to name, but you constantly give your amazing support and positive energy and it truly means the world to me.

THE AUTHOR

Lan Nguyen-Grealis is an award-winning makeup artist with over a decade of experience in all areas of the fashion and beauty industries, from magazine editorials to celebrity shoots and catwalk shows. Born in Ireland of Vietnamese descent, she studied fashion at Central Saint Martins before becoming a makeup artist. Her work has featured in Russian *Vogue*, *Vanity Fair*, *Elle* UK, *Glamour*, *Grazia* and *Stella* magazine. She is currently beauty editor of *Phoenix* magazine and published her first book, *Art & Makeup* in 2015.

Lan was the first makeup artist to present a catwalk show at London Fashion Week solely dedicated to the art of makeup, the event attended by many celebrities and respected industry peers. She is dedicated to bringing makeup to the forefront of the industry, proving it is an art form in its own right.

You can find Lan constantly working in all areas of the media, collaborating with various brands and beauty editors, sharing tips and tricks. Through her love of education, Lan also shares her knowledge by appearing on TV, delivering talks on stage and teaching in schools globally.

For more information visit
www.lan-makeup.com